Images of
Dublin

A Time Remembered

Images of
Dublin

A Time Remembered

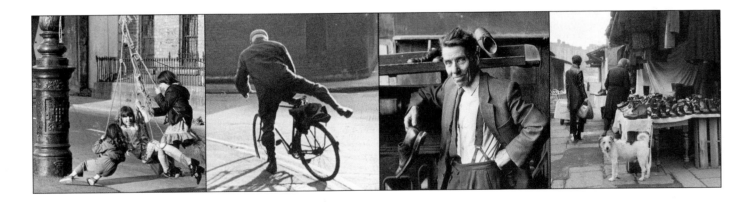

Photographs by Bill Doyle

Introductory essay by Benedict Kiely

THE LILLIPUT PRESS • DUBLIN

To the people of Dublin

Photographs © Bill Doyle, 2001
Introductory essay © Benedict Kiely, 2001

First published 2001 by
THE LILLIPUT PRESS LTD
62-63 Sitric Road, Arbour Hill, Dublin 7, Ireland.

A CIP record is available from the British Library.

1 3 5 7 9 10 8 6 4 2

ISBN 1 901866 74 2

Special thanks are due to Antony Farrell, Hetty Walsh, printer, and Betty White.

Set in Bembo. Design by Karen Carty at Anú Design.
Printed and bound by Estudios Gráficos Zure, Bizkaia, Spain.

CONTENTS

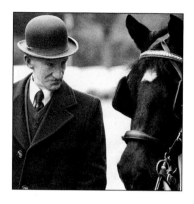

INTRODUCTORY ESSAY

Dublin, the metropolis of Ireland, is situated in the province of Leinster, in the county of Dublin: at the bottom of a fine bay, about eight miles in diameter; called, after the city, Dublin Bay. The River Liffey divides the town into two nearly equal parts, and empties itself into the bay about half a mile below the present city. Dublin is the second city in His Britannic Majesty's dominions, and may rank with the very finest cities of Europe, for extent, magnificence and commerce …

Walton's Dublin, 1799

The way to discover Dublin, said Tom Stanley to me, is this: 'Go in to the Pillar, beside the GPO. The Nelson Pillar to you. Take any tram there to that tram's terminus and then walk back to the Pillar: walk every step. When you've covered every route, out by tram and back on the loop, you'll know Dublin.'

That Tom Stanley was a devoted Dublinman, one of a large family who lived around Fairview and were in the plumbing business. Tom had wedded my eldest sister, Rita.

Well, even a little fellow like myself knew where to find the Pillar, and knew who the fellow was, or was meant to be, who stood on top of it, and knew that when you went down the steps from Amiens Street railway station you could see him away up there keeping his cold English eye (only one) on O'Connell Street and the traffic of Dublin City, and all of the Irish.

From Amiens Street station to the Pillar would be my first Dublin march on parade. And I painfully followed Tom Stanley's advice on how to discover the rest of Dublin. It worked and my memories have never faded.

One day, many years ago, I went into a pub in the Ballsbridge area of Dublin City, with nothing better on my mind than the making of a telephone call. And found myself, as one so often does nowadays, without the necessary open-sesame coinage. So, rattling miscellaneous fragments in my fist and approaching the counter, I said to the barman, and over the heads of the front-row forwards: 'Would you have two single-shillings?'

The conversation along the counter, the rattle of the cash-register, even the piped music seemed to die away into silence. And the front-row forwards swivelled round and took a serious look at me.

If in age you are over fifty, or worse still, if you are over sixty, or, far-and-away worse, if you are over seventy, you may have noticed the number of young people who now infest the pubs and make them quite uninhabitable: no style, no conversation. It wasn't at all like that when I was young. A friend of mine, a notable man in the theatre and on television, said to me one day: 'All the men I once drank with are either cured or dead.' And there are moments when I feel like standing up, with a little help, on a bar stool and proclaiming: 'I drank as a friend, though younger than they were, with R.M. Smyllie, a great editor, and M.J. MacManus, a great literary editor, and Austin Clarke (a very moderate drinker but a very great poet), and Brinsley MacNamara, great novelist who shook Ireland when he wrote about the Valley of the Squinting Windows … and with others. Many others. And where did you all, you front-row forwards, holding on to the counter with your elbows as if you owned that counter, where did you come from, all of a sudden?'

But the barman, on that day in Ballsbridge, was a bit older than most of his customers. And he was a sympathetic man. He said: 'It's a long time now, since I heard anyone talking about single shillings.' He spoke like a man remembering the Night of the Big Wind.

'I'll bet', he said to me, 'if you get on a bus going in to Dublin Town, you say the Pillar and never the G.P.O. Nor An Lár. Wherever that may be in this world or the next.'

I admitted that I did, indeed, say, or at any rate think, the Pillar. Although, as we all know, the Nelson Pillar has been gone there many years.

Horatio Nelson stood up there for a long time and was respectfully nodded to by generations of Dubliners and their ladies, and visitors. The poet Louis MacNeice, whom I had the honour of knowing as a friend, walked past there in the darkest days of World War II and, afterwards, when writing splendidly about Dublin wrote of 'Nelson on his Pillar watching his world collapse'. You could, at that time, pay threepence, and go up ninety-nine steps, and stand at the feet of Nelson and get a fair view of the city; the line of the Liffey there and the blue hills beyond.

Poor Nelson, whose sight was never of the best, hadn't much longer to stand up there to watch anything. Some time in the 1960s some imbeciles, or worse, put in a bomb and knocked him off his foothold. Away in Oregon I was at the time, and another fine poet, Robert Tarren, wrote to me to comment sadly on the minds, if that would be the word, of the sad cases who could only think of destruction. An army explosives crew had to clean up and remove the remains of the Pillar, a fearful task, one of them told me long afterwards. That Pillar was solidly based. So was the Empire at the time of Trafalgar.

There was a teenage ballroom dance that evening in the Metropole, and many of the young people, including my daughter, Anne, stepped out in the middle of the boom. Mercifully and miraculously nobody was even scratched.

All this the good man in the pub in Ballsbridge, and myself, discussed learnedly, rationally and sympathetically. I had admitted that I still might get into a bus and tell the conductor (conductors then still existed) to drop me at the Pillar which no longer existed.

'I do worse,' he said. 'Or better. If I'm getting off at the statue of Daniel O'Connell, which is still there, I say, "drop me at the Grand Central".' Which is no longer there.

Then suddenly I saw again the old Grand Central Cinema and even remembered my first visit there. Oh, it was by no means as splendid an occasion as when that precocious boy, or young fellow, or changeling, or whatever he was, Marcel Proust (for it is often if not always difficult to guess at the age of the Proutsian narrator) was brought for the first time to see Therma the Divine on the Parisian stage. 'My pleasure increased further', Proust remembered,

when I began to distinguish behind the lowered curtain such obscure noises as one hears through the shell of an egg before the chicken emerges, sounds which presently grew louder, and suddenly, from that world, which was impenetrable to our eyes, yet scrutinised us with its own, addressed themselves individually to us in the imperious form of three consecutive thumps as thrilling as any signal from the planet Mars.

No, the Grand Central was never quite on that level. But when my sister Rita and her Dublinman of a husband first brought me there, I was young enough, about fourteen, to be so mightily impressed that I still remember the movie. It was called *Five Star Final*, and there was Edward G. Robinson pretending to the editor of a newspaper in some American city, a sensational newspaper, a sort of scandal sheet. As so many newspapers nowadays, in a sort of soft-porn way, are. One of the stories that Robinson's paper prints leads to a woman's suicide. And one of the scenes that stays with me to this day showed the woman's daughter rushing into the editor's office and crying out: 'Why did you kill my mother?' And Edward G. Robinson, with a masterly blend of genuine sympathy and fearful irony, says: 'We killed your mother for circulation.'

I cannot remember how long ago that was. I can easily remember that it was in 1932 that I paid my first visit to the old Metropole Cinema, now, as all old Dubliners know, no longer there. Gone! In the company of the old Capitol, which flourished just around the corner. And the Grand Central had two alcoves, most certainly made for whispering lovers. All gone – along with the palatial Theatre Royal itself, and all its most substantial pageants, and leaving not a wrack but a liner-load of memories behind. And all those splendid cinemas and theatres taking with them their fine restaurants and teashops. And what else? Whisper.

But my first visit to the Metropole, in the course of my introduction to Dublin City, is easy to date because it was the Big Sunday of the Eucharistic Congress which Jehovah, or somebody acting in His Name, ordained for AD 1932. And never was there,

before or since, such a crowd on O'Connell Street (although, with tourism and motor traffic nowadays, you never can tell).

The best way still to go in search of Dublin City is on foot. Since my final settlement in the city in 1940 I have graced five different quarters of the great town. Ballybough, again, and Fairview, neighbours to each other and on the north side. And Dollymount, at the far end of Clontarf and then, practically, on the northern fringe of the city. Then southwards across the Liffey to elegant Rathgar. And then to Donnybrook where, to the historical imagination, the echoes of the famous, or notorious, Donnybrook Fair can still be heard. Through Ballybough and Fairview there stalked, after 1941, the ghost of that young man by the name of Joyce. And he walked before me as I trudged across town to University College, Earlsfort Terrace, Dublin. Where in the neighbourhood one might also encounter the ghosts of John Henry Newman, and Gerard Manley Hopkins, and Thomas MacDonagh. And many others. Over the years the gathering of ghosts continues to grow.

From my study window in Dollymount I could look down on the Strand and the Bull Island where Joyce sent Stephen Dedalus, created by Joyce in his own image and likeness, walking to see the goddess of a girl wading in the salt water. And I could also look across the Bull Island to Howth Head. And southward across the bay to the ever-present Dublin and the Wicklow mountains.

And this great various world of Dublin and its people is once again here before me, brought to me, all to be enjoyed and cherished in Bill Doyle's photographs, visions of the city and its people. They are all here – wonderful memories and images to delight the eye and tease the memory.

The fine vision of Bill Doyle. It fills my eyes and warms my heart. Bill Doyle has the vision and can record it.

BENEDICT KIELY, *Dublin, August 2001*

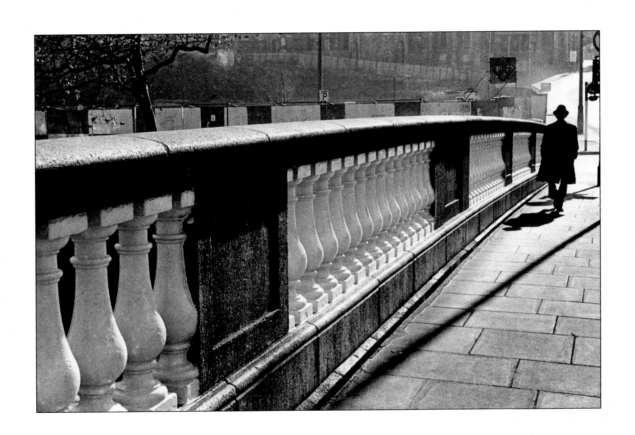

1

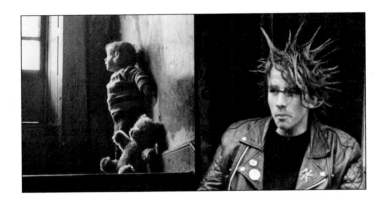

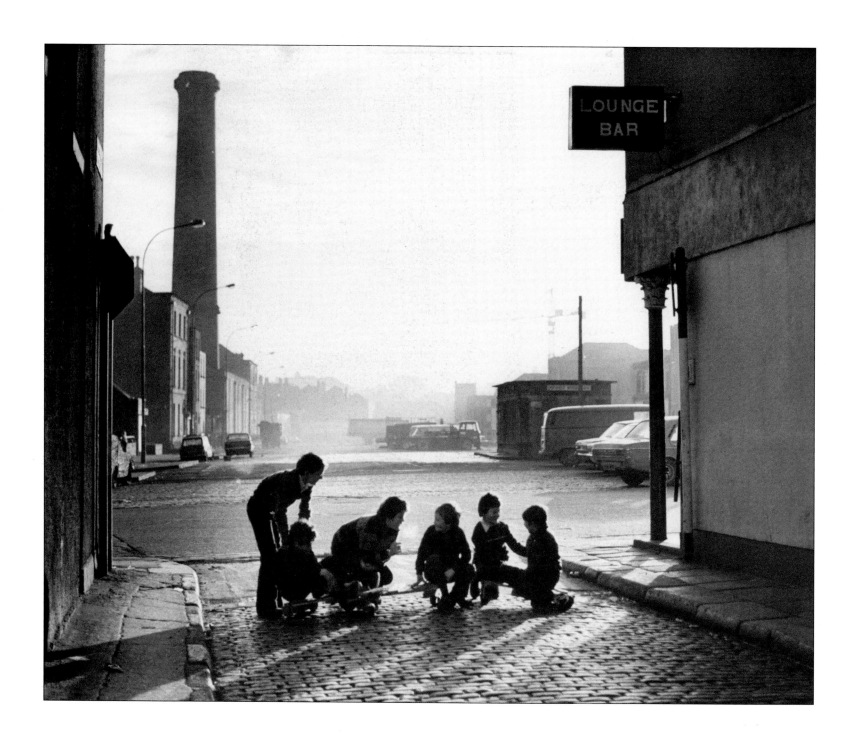

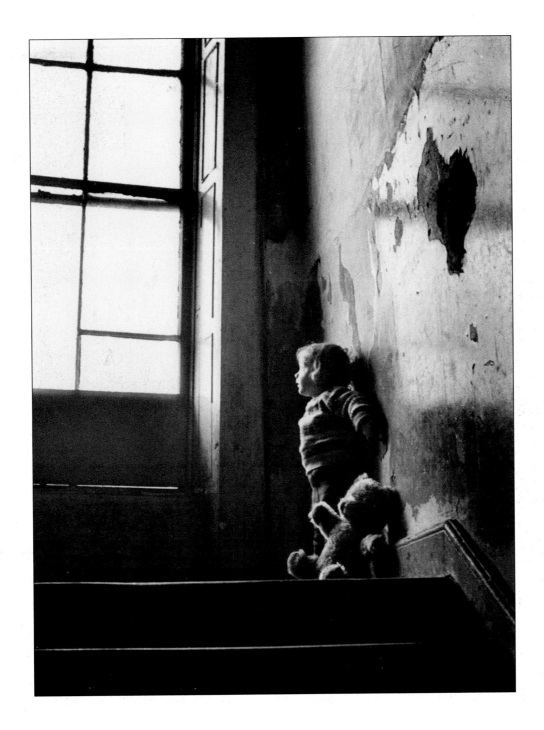

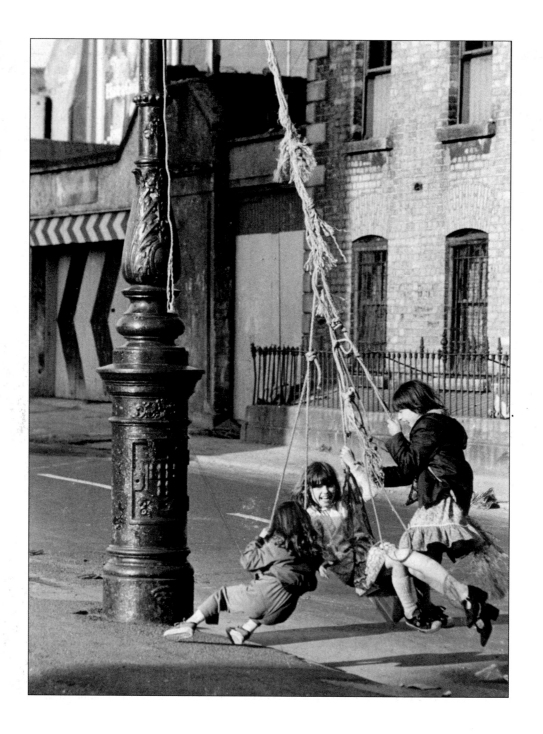

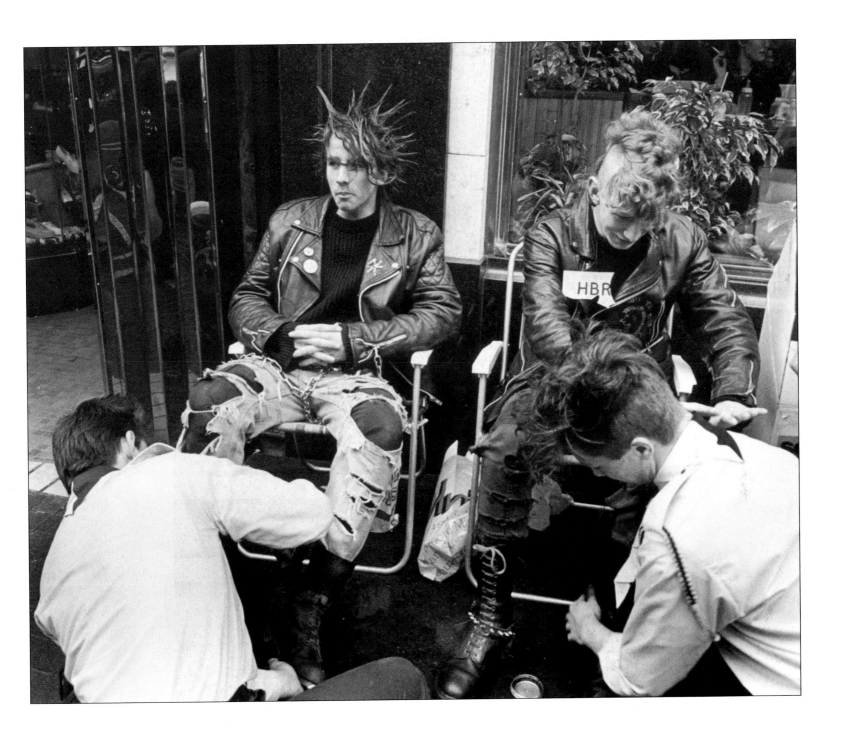

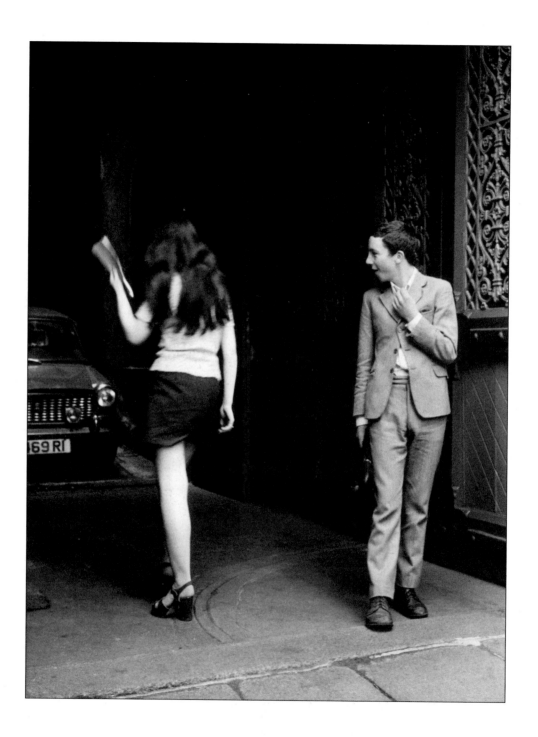

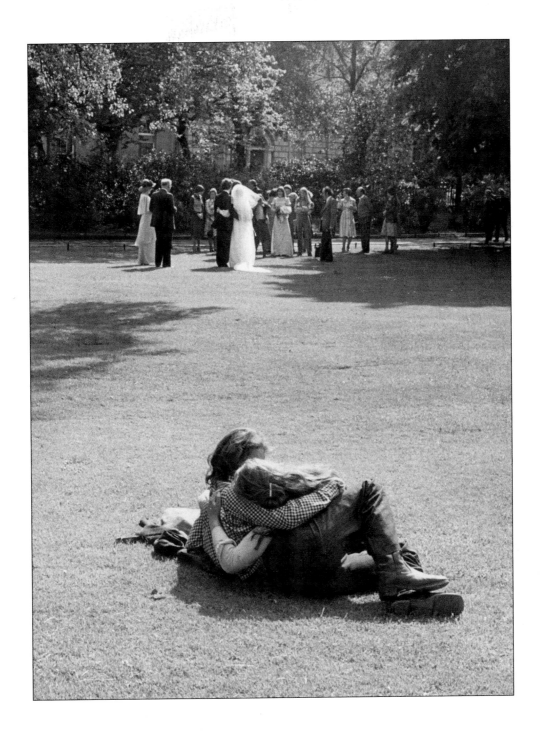

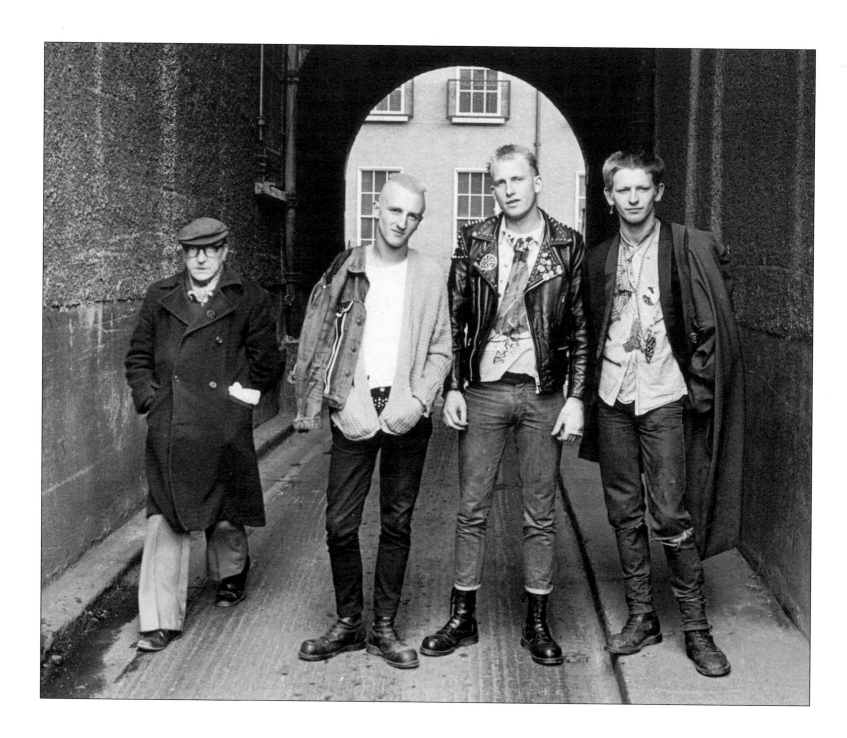

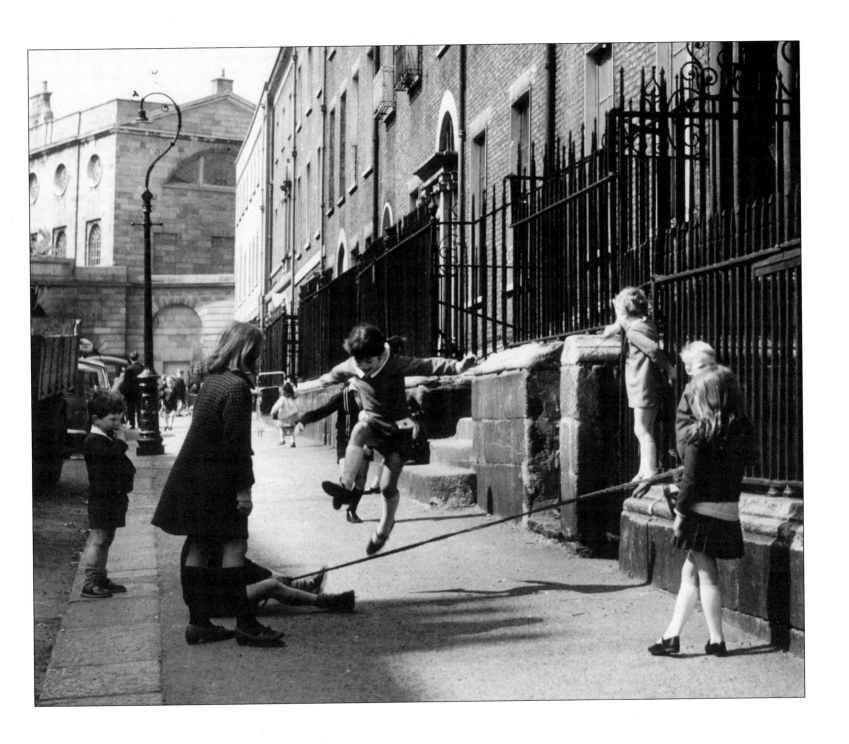

2

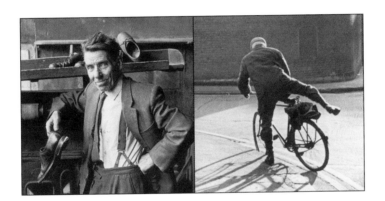

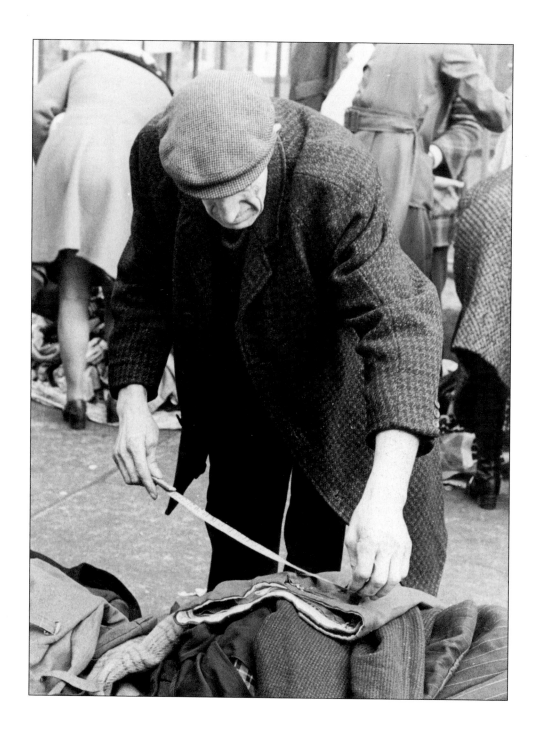

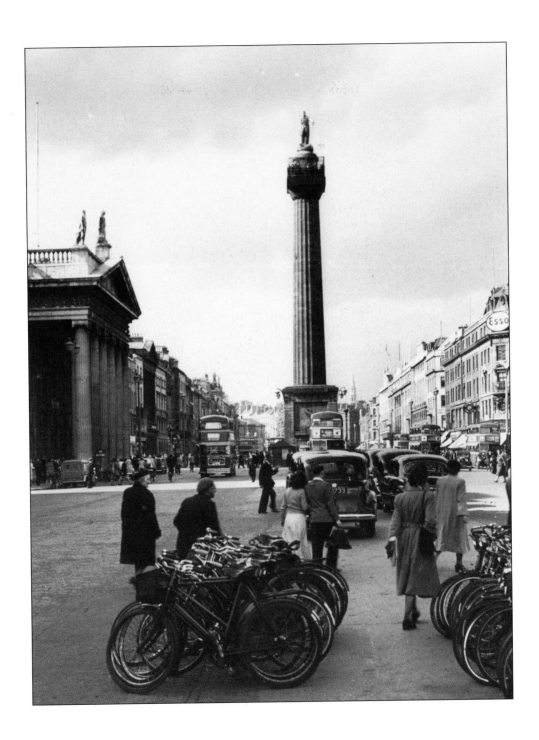

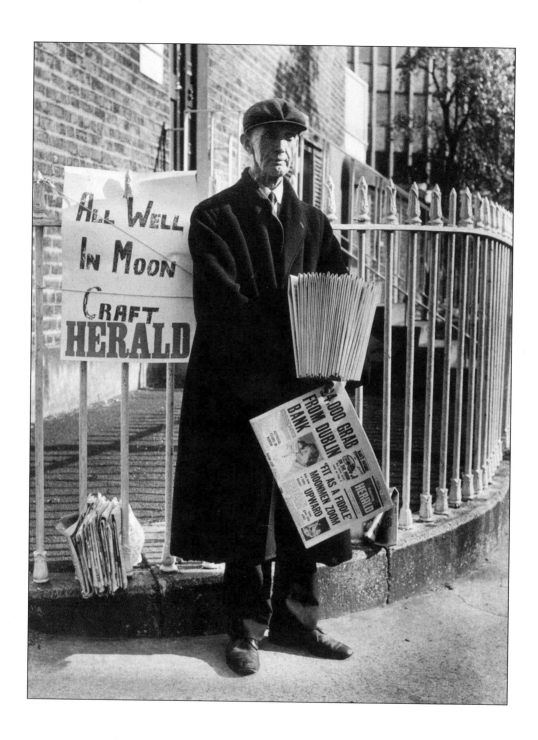

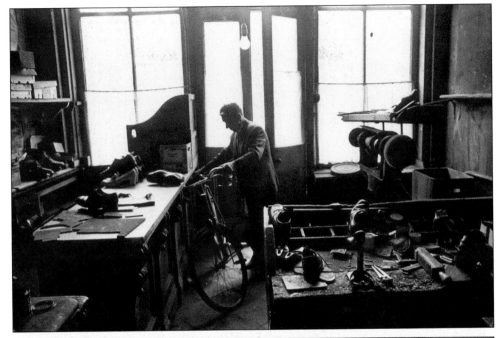

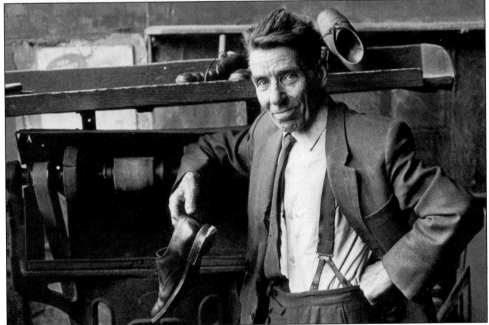

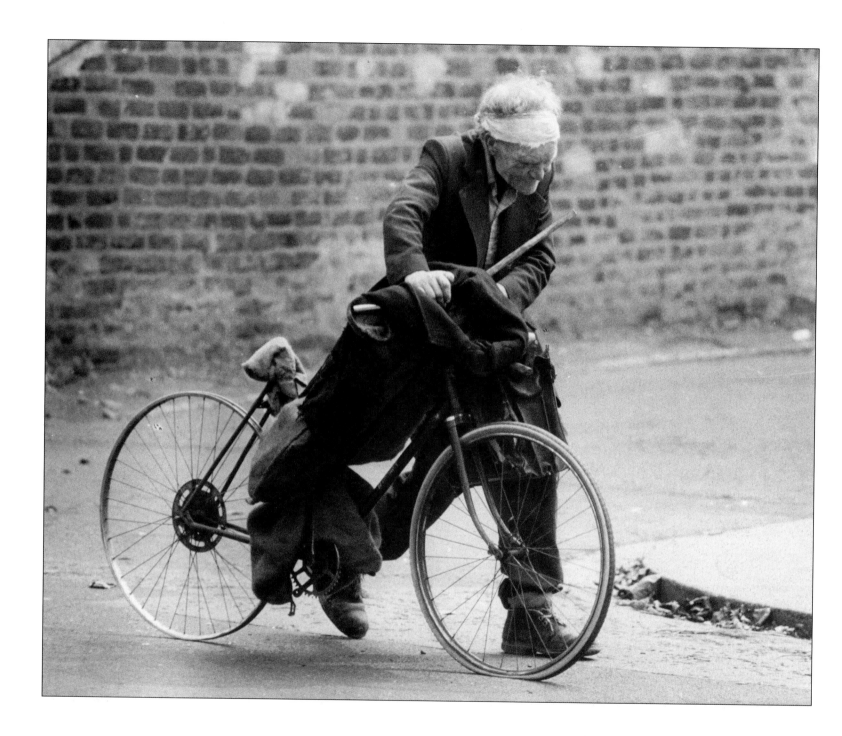

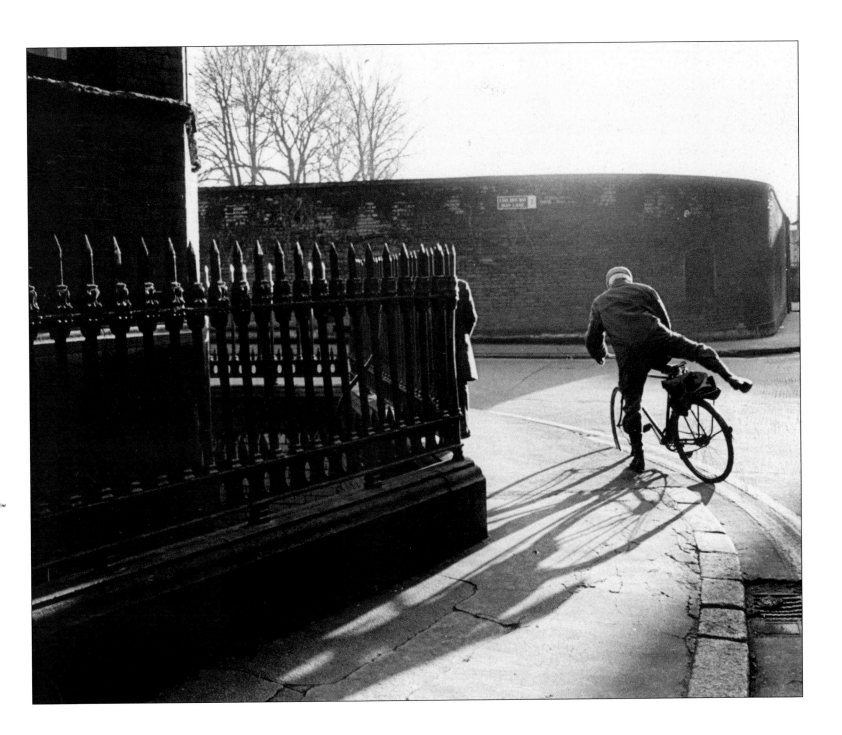

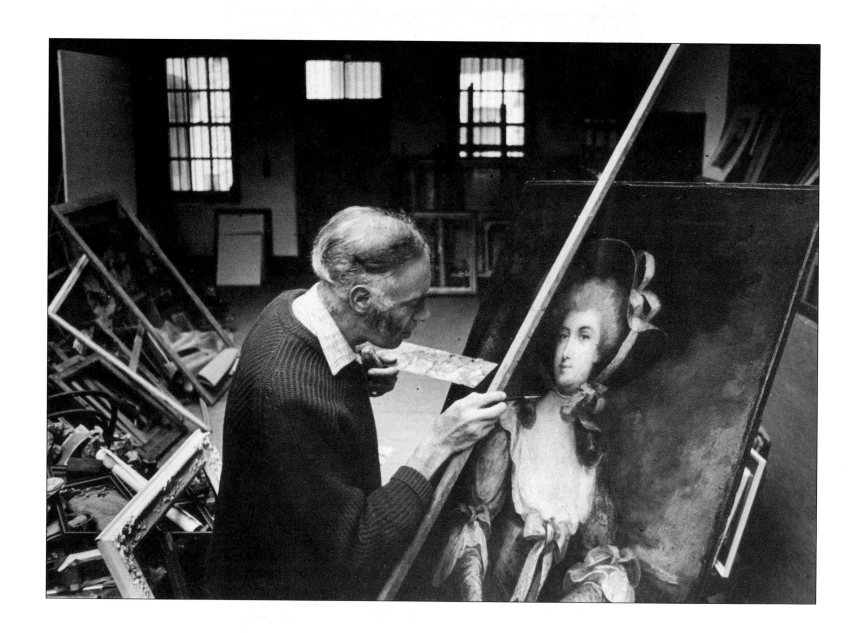

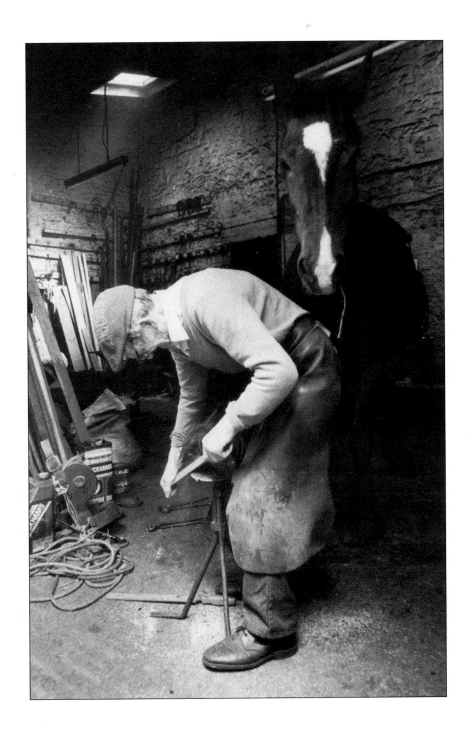

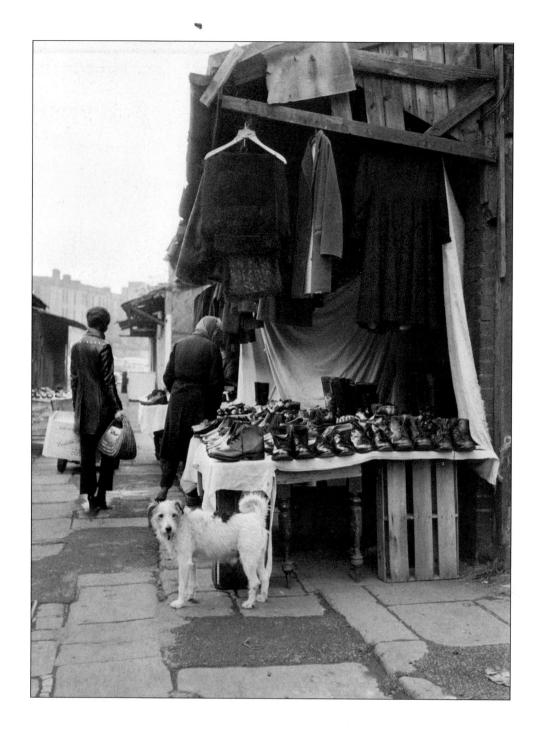

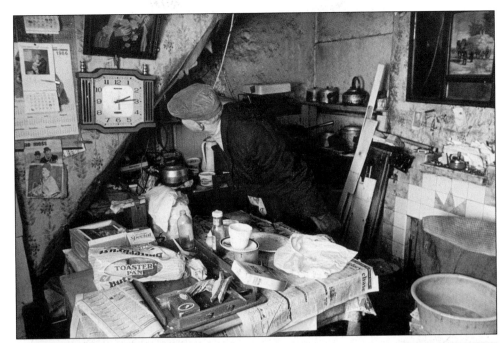

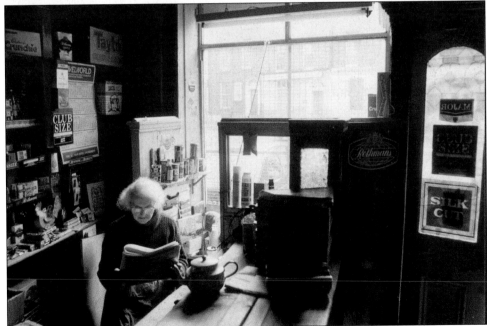

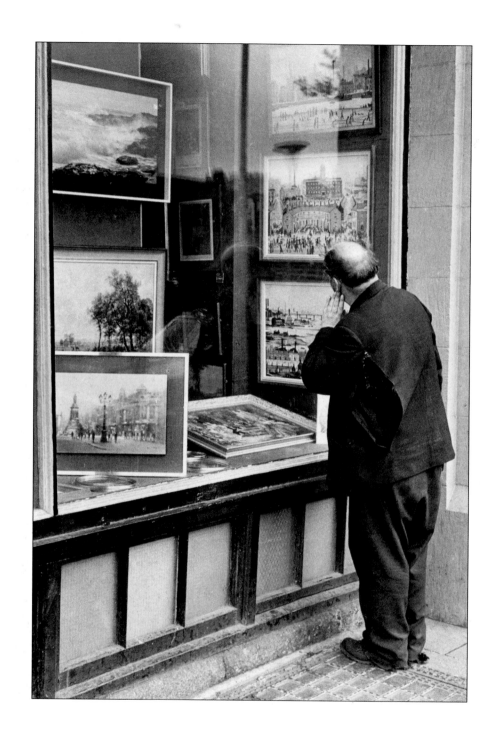

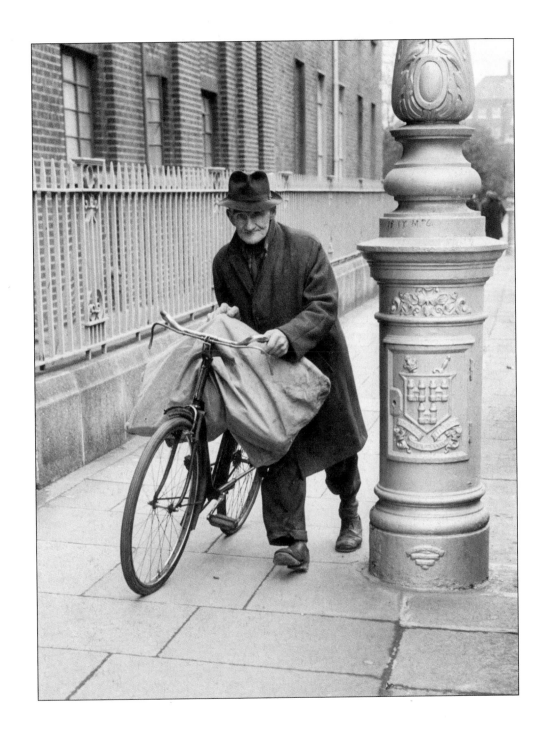

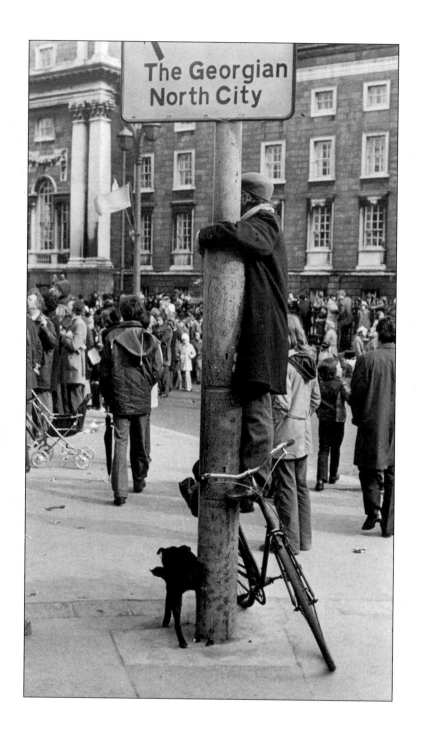

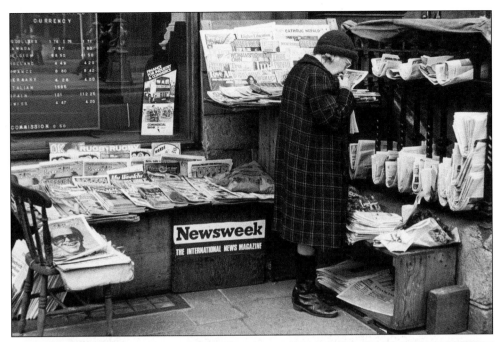

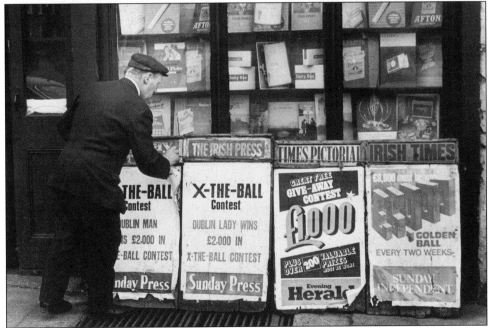

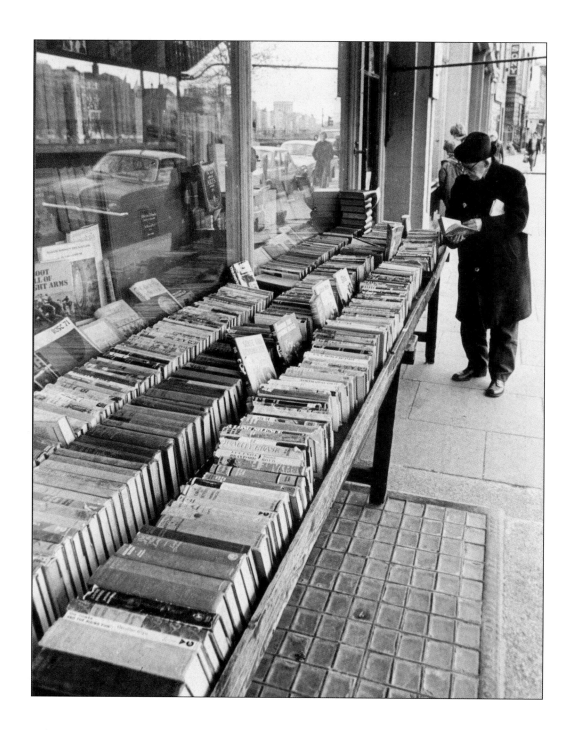

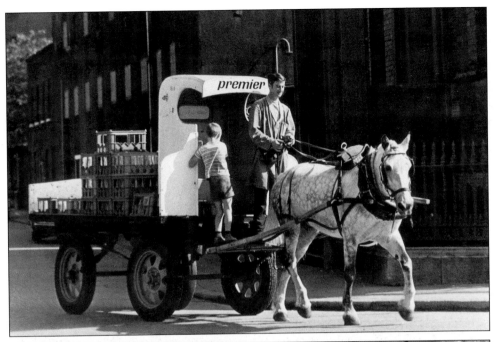

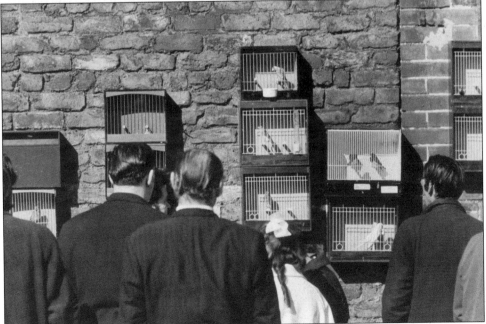

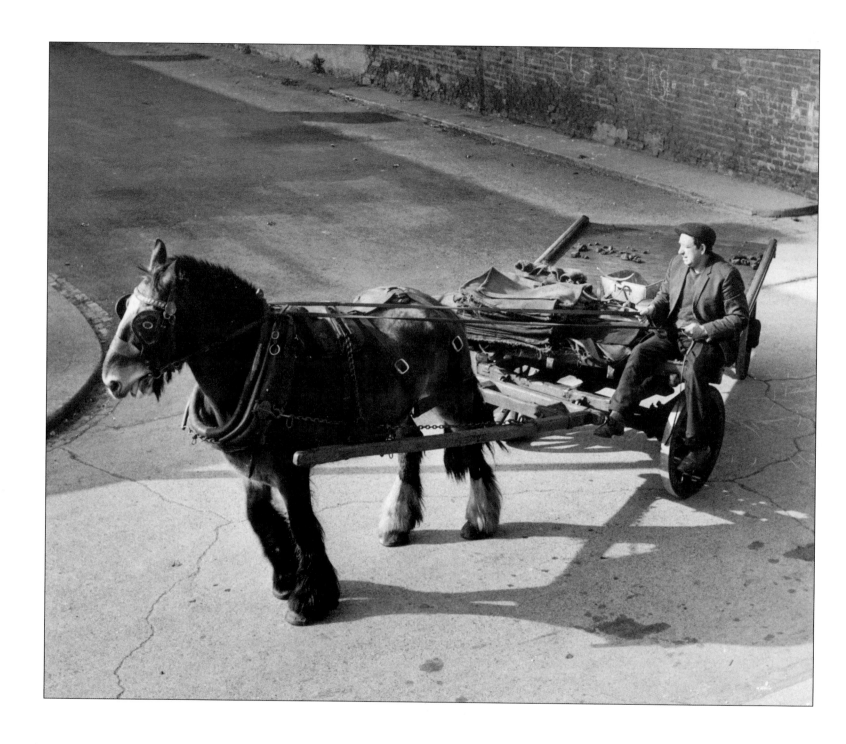

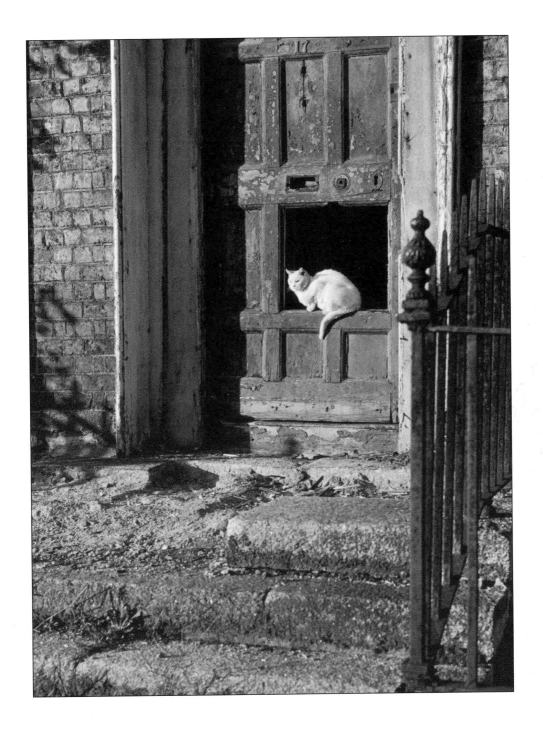

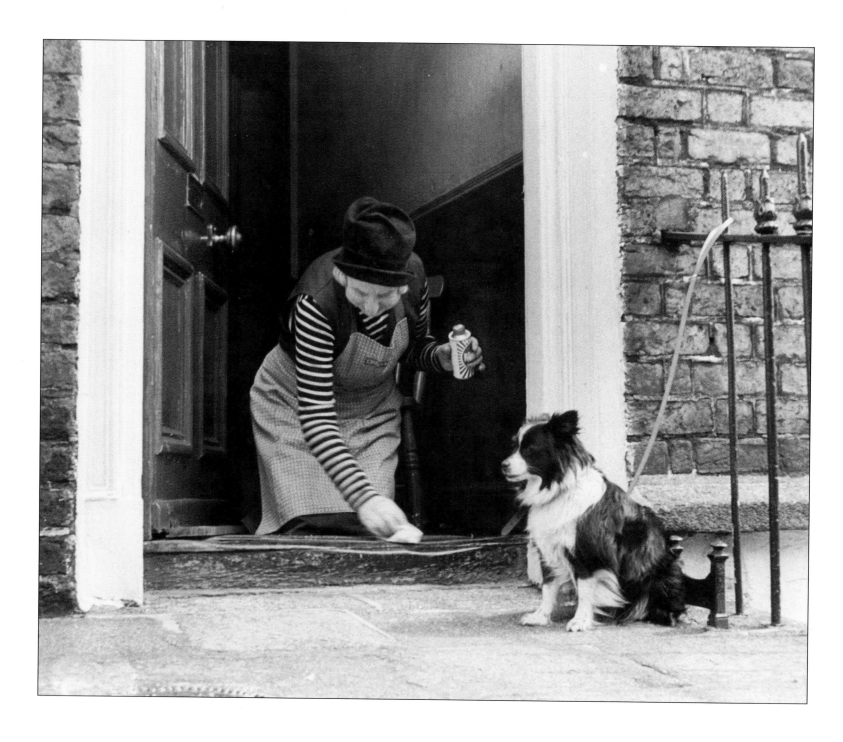

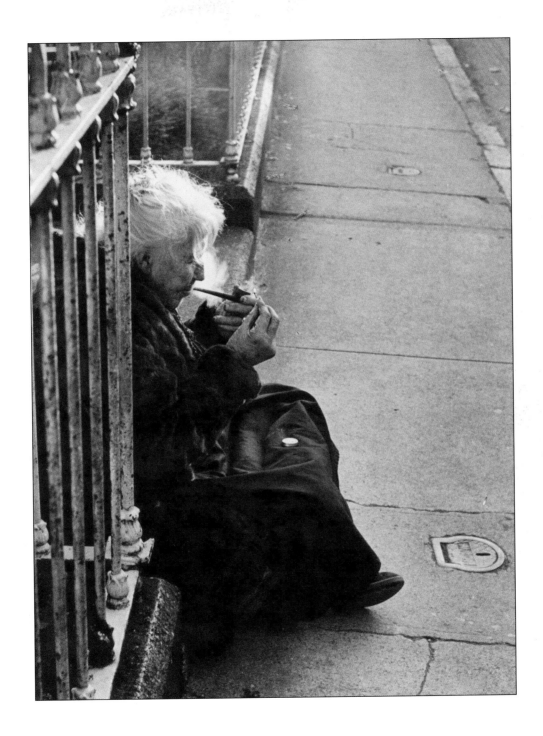

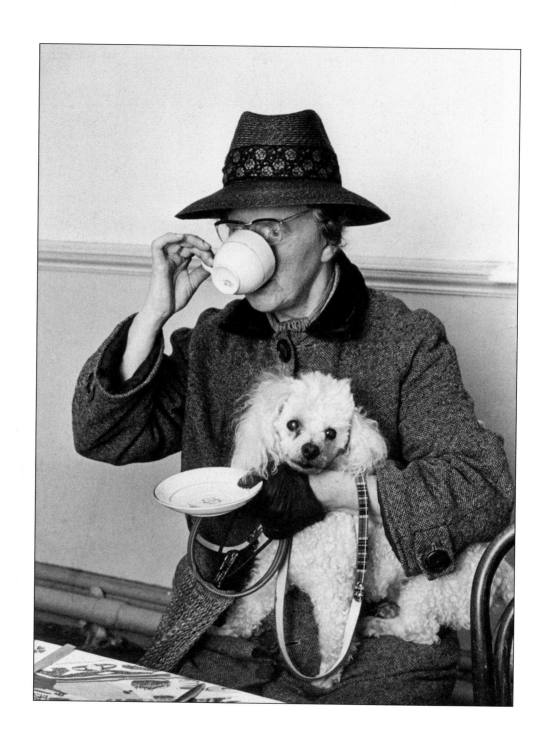

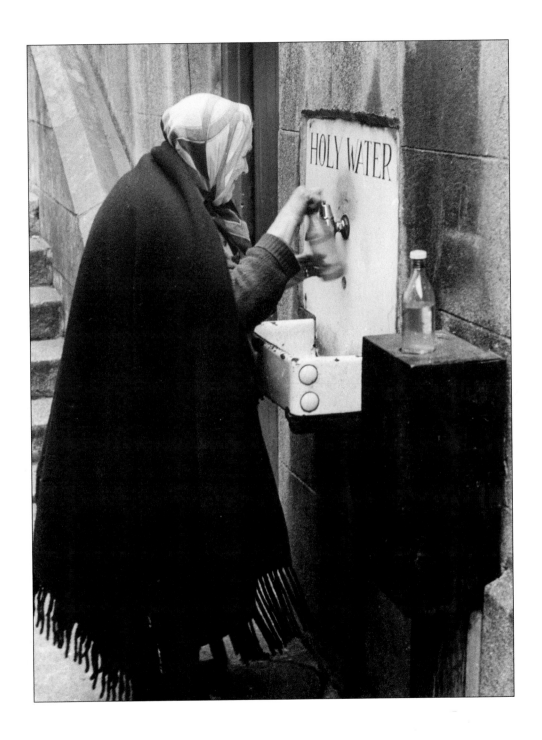

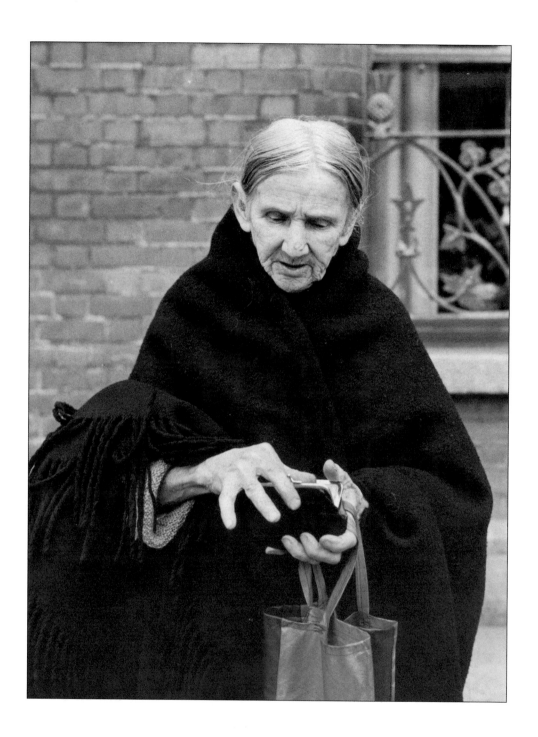

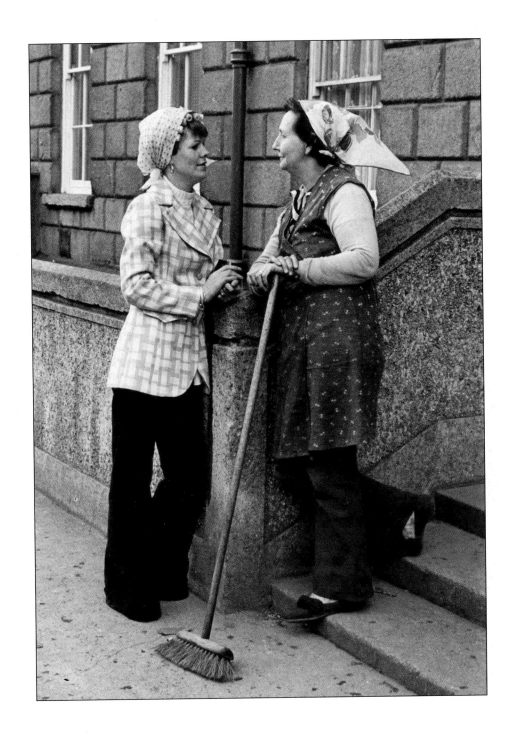

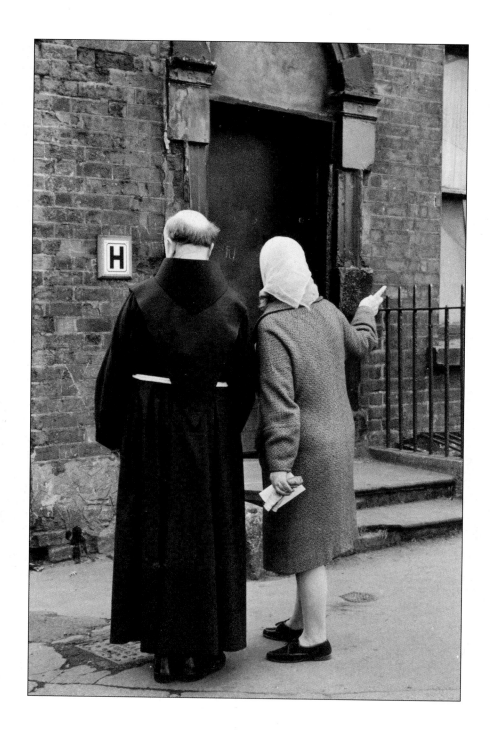

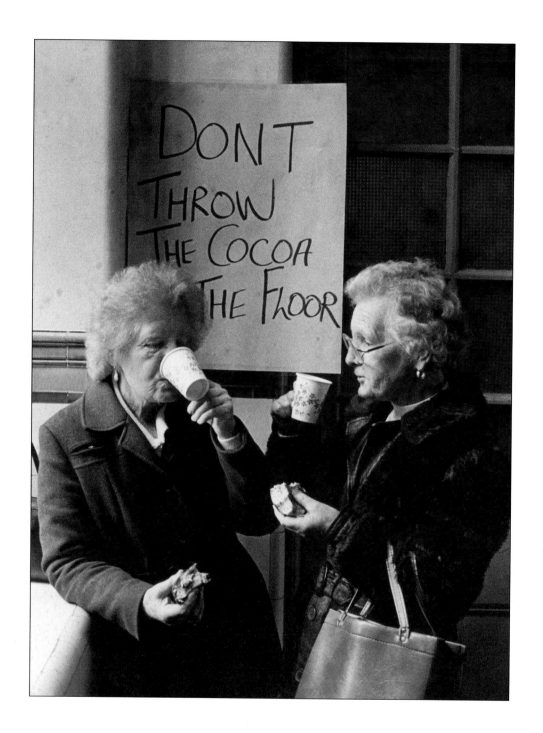

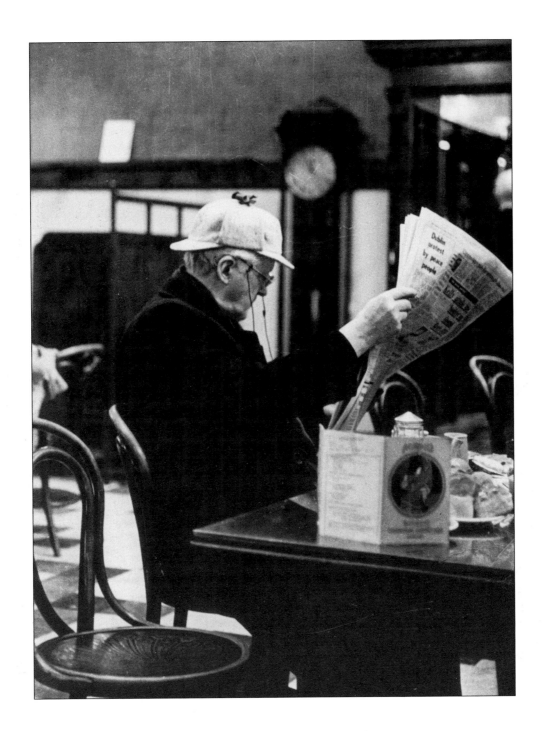

3

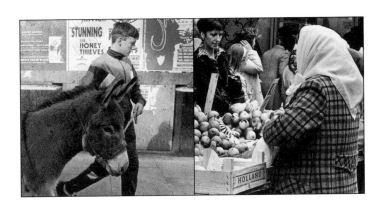

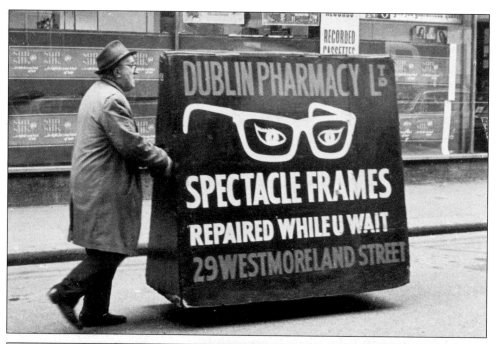

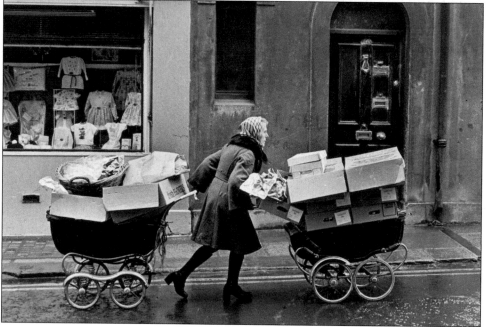

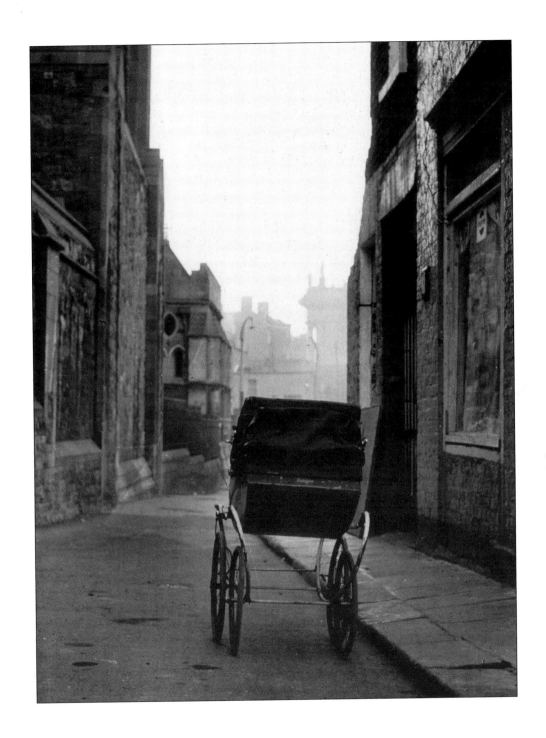

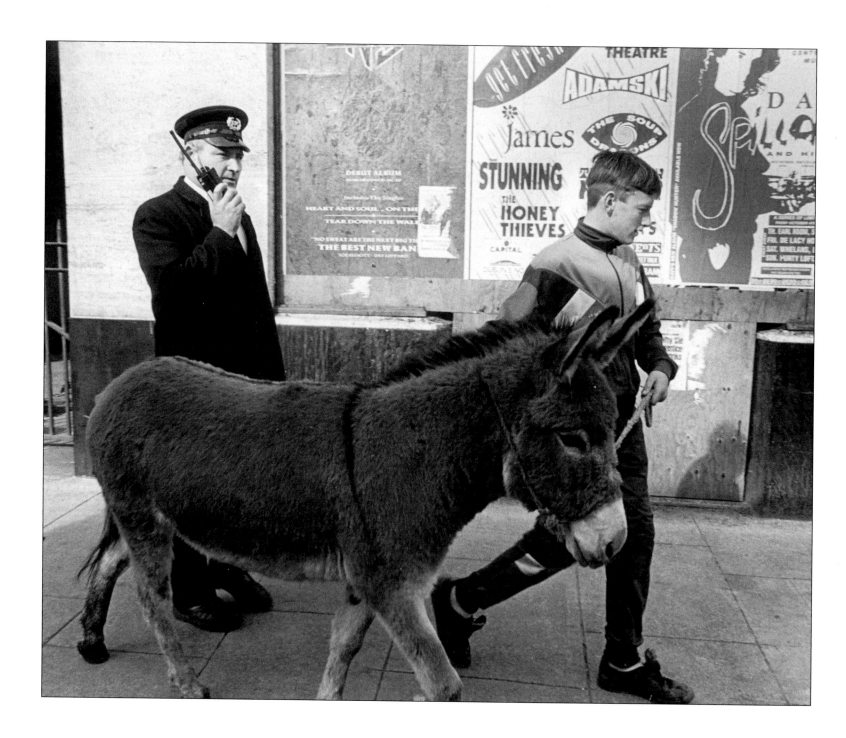

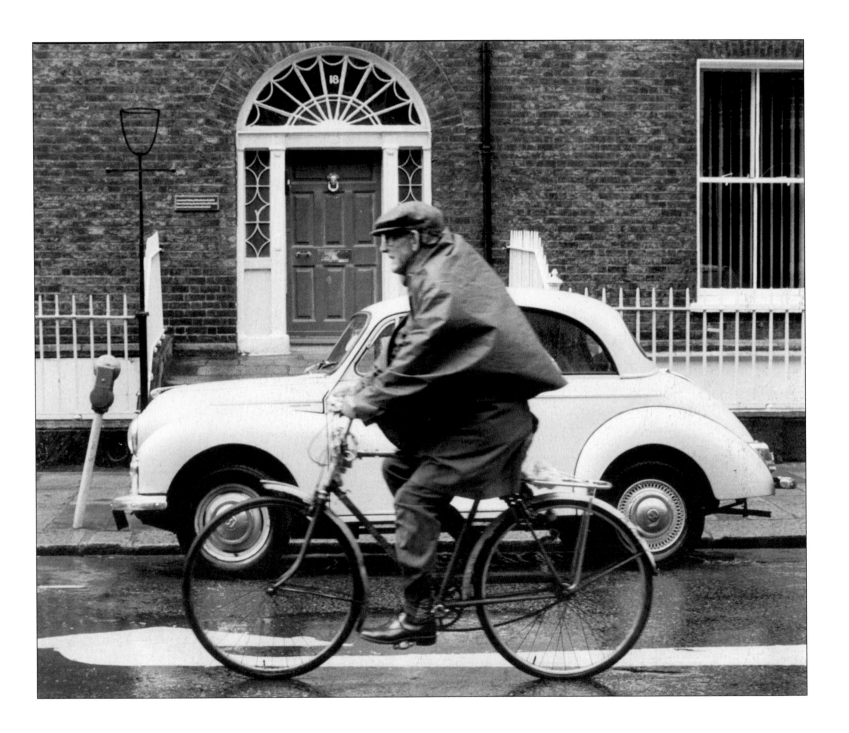

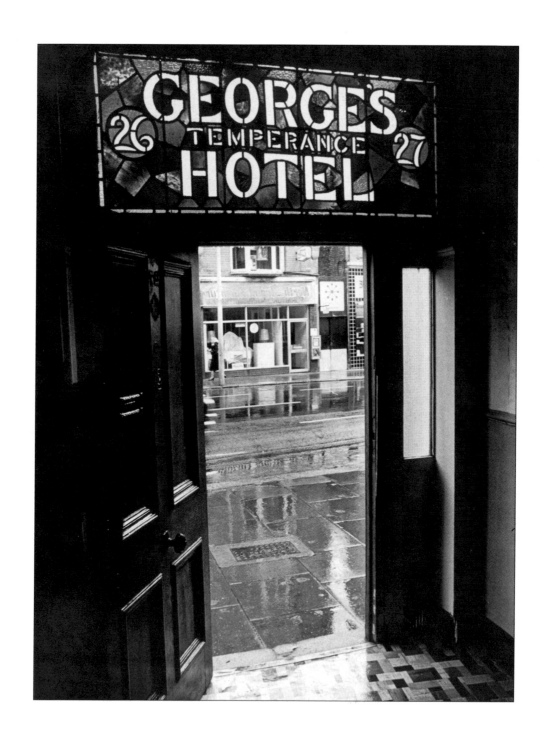

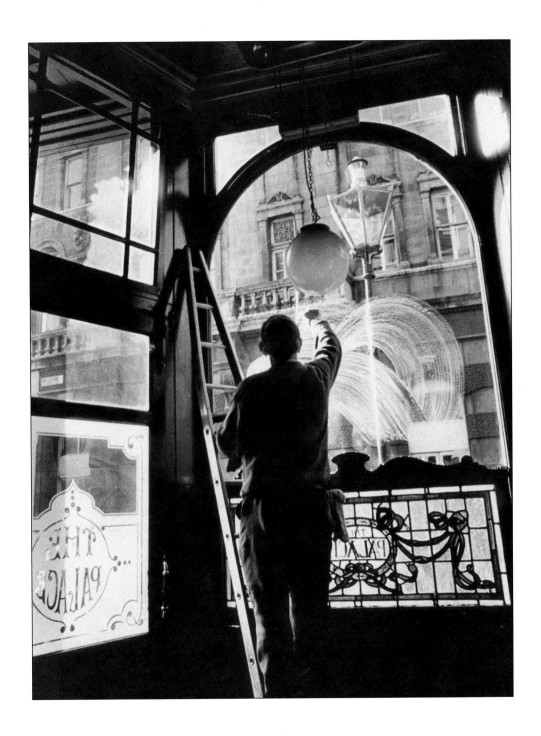

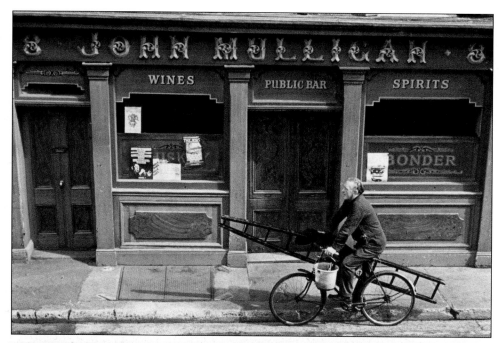

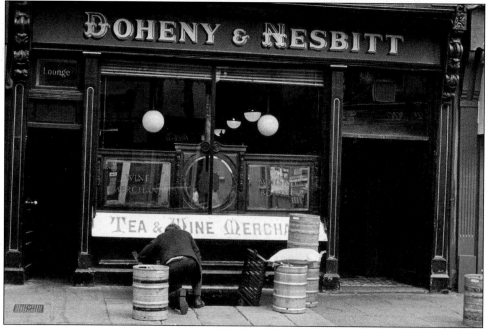

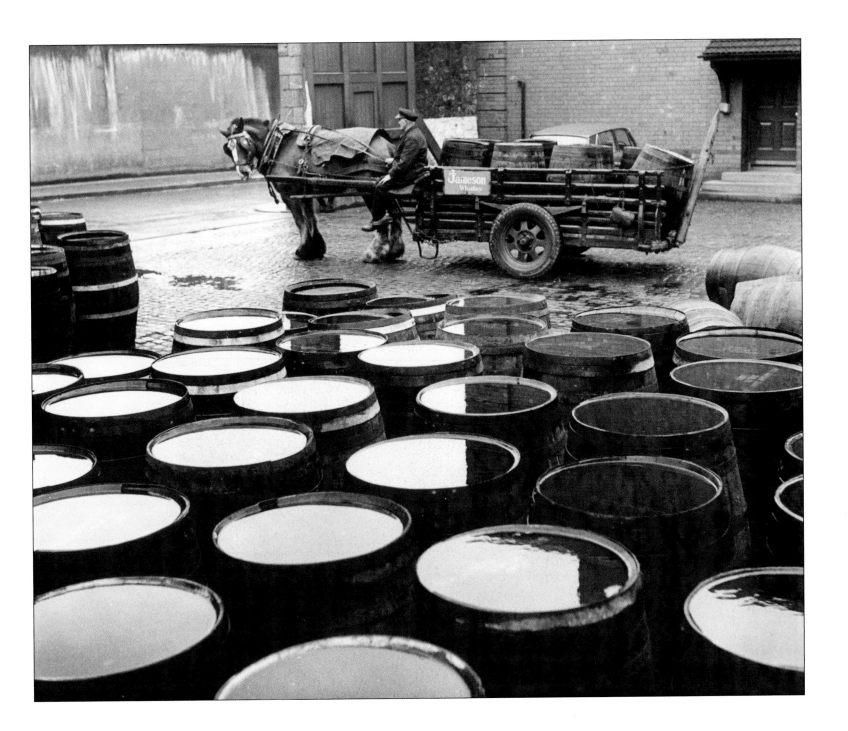

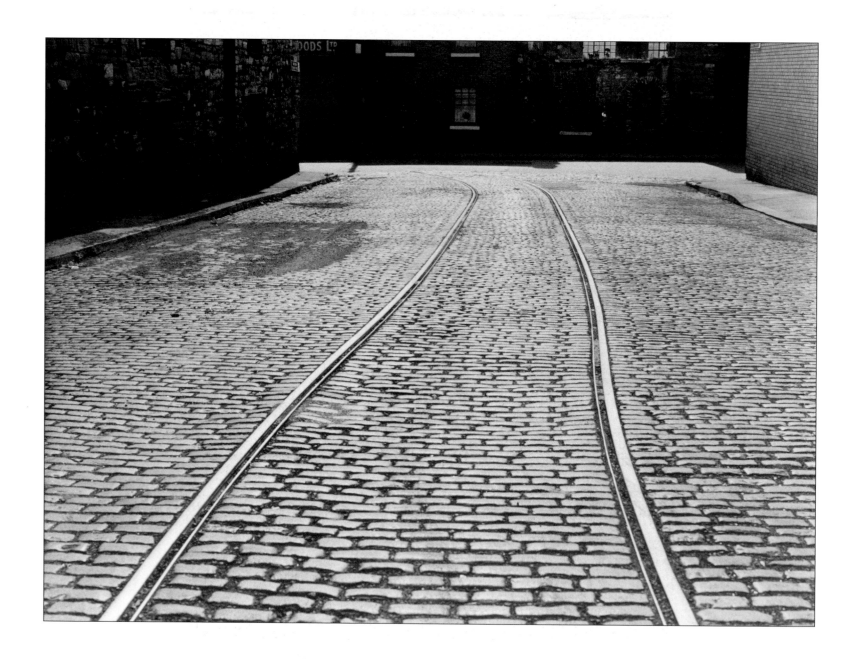

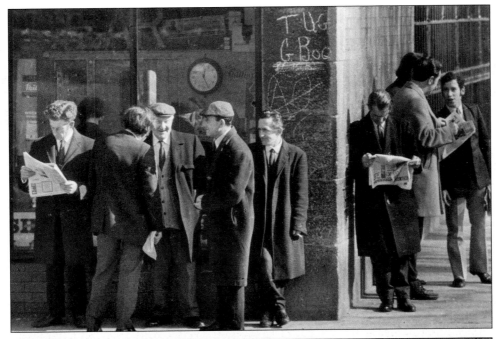

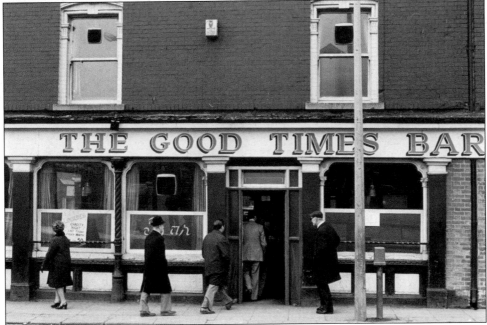

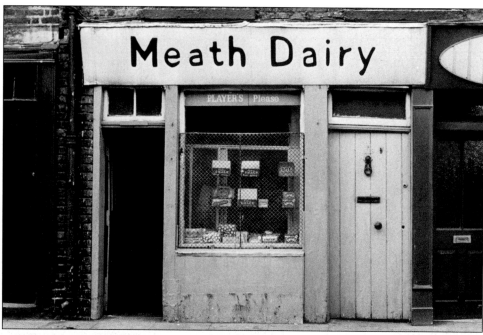

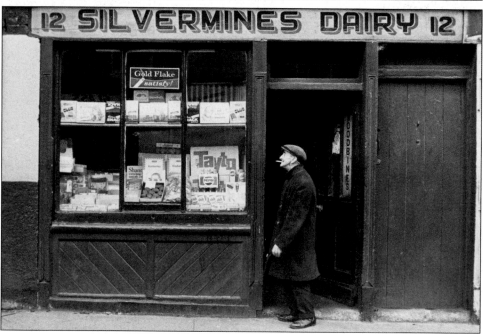

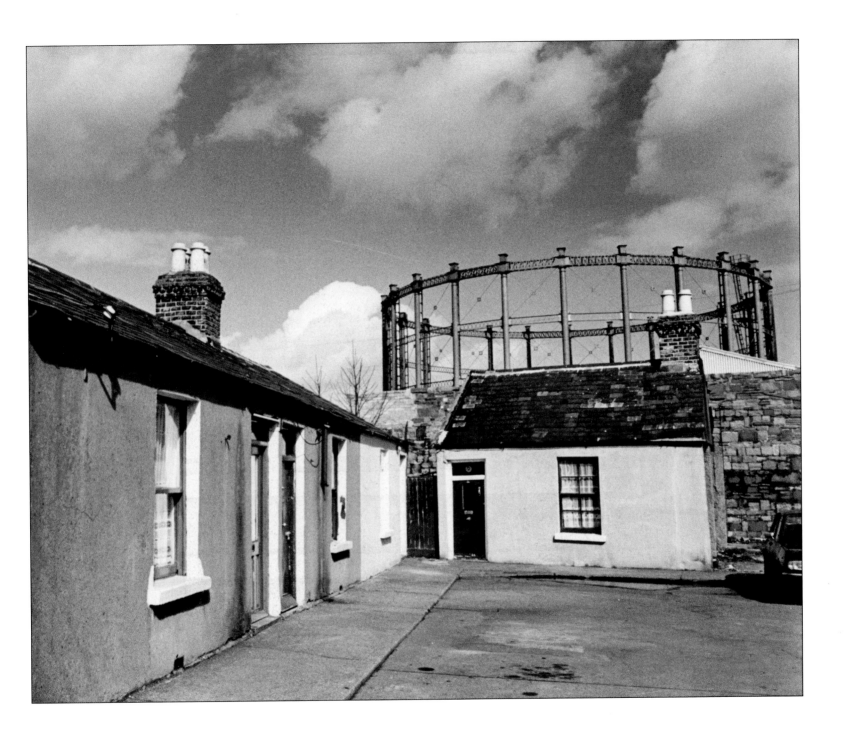

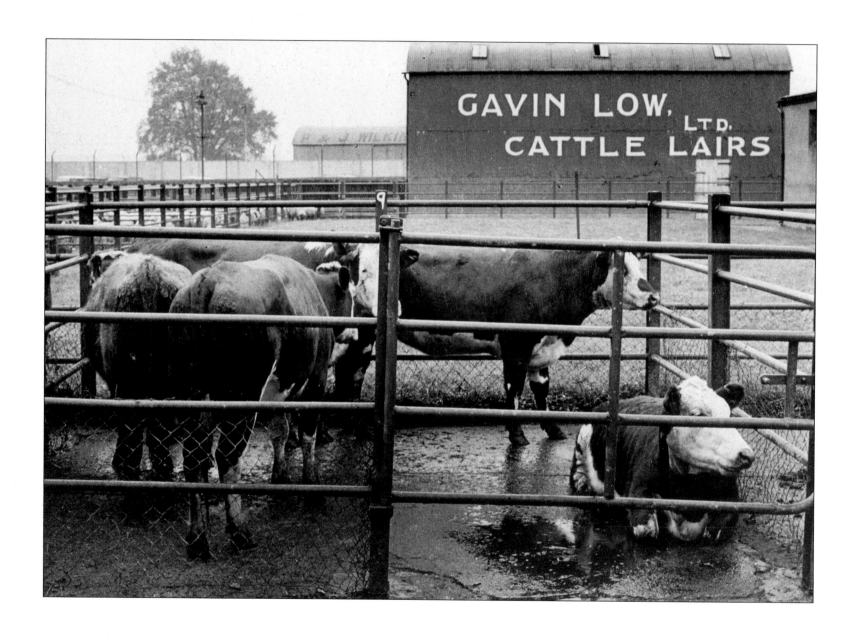

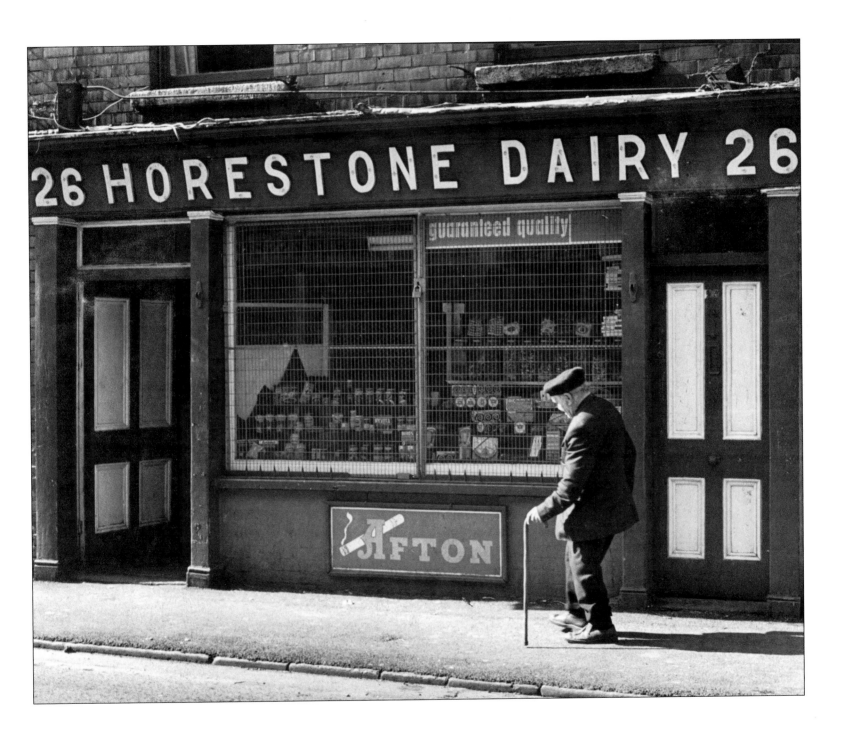

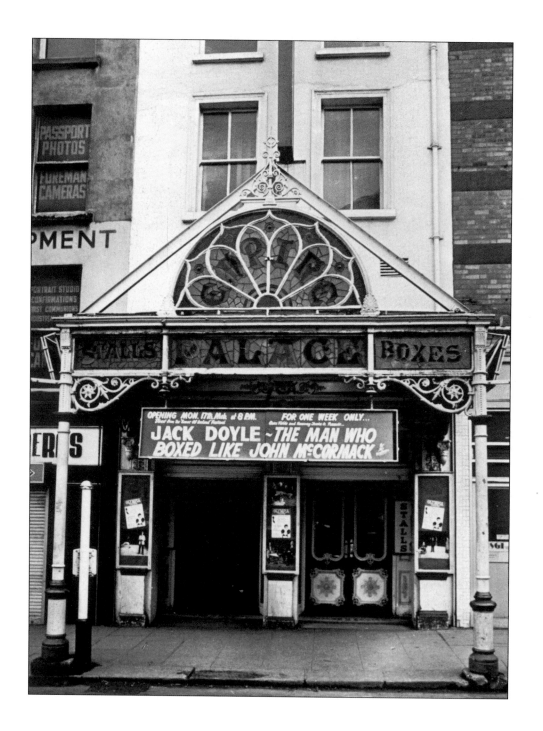

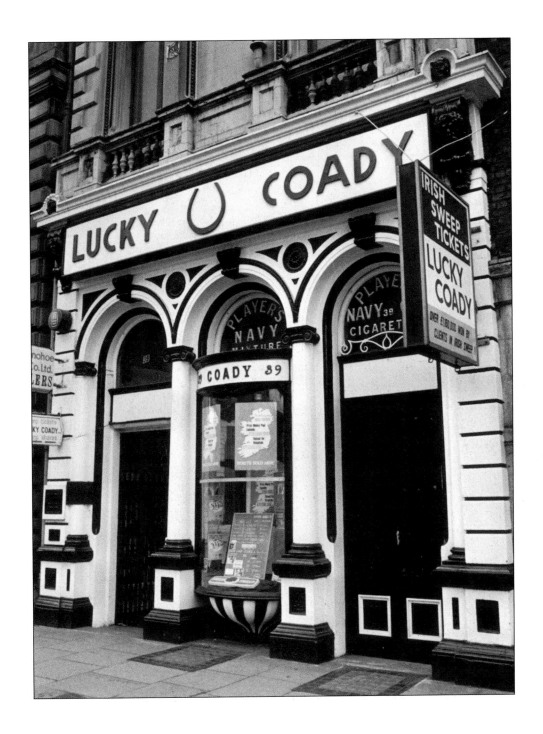

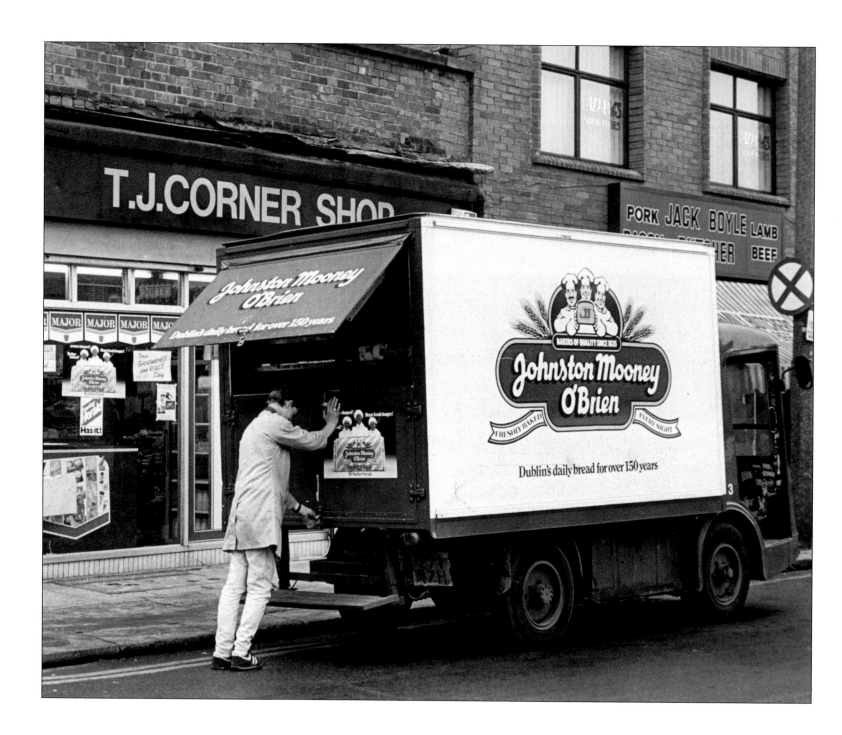

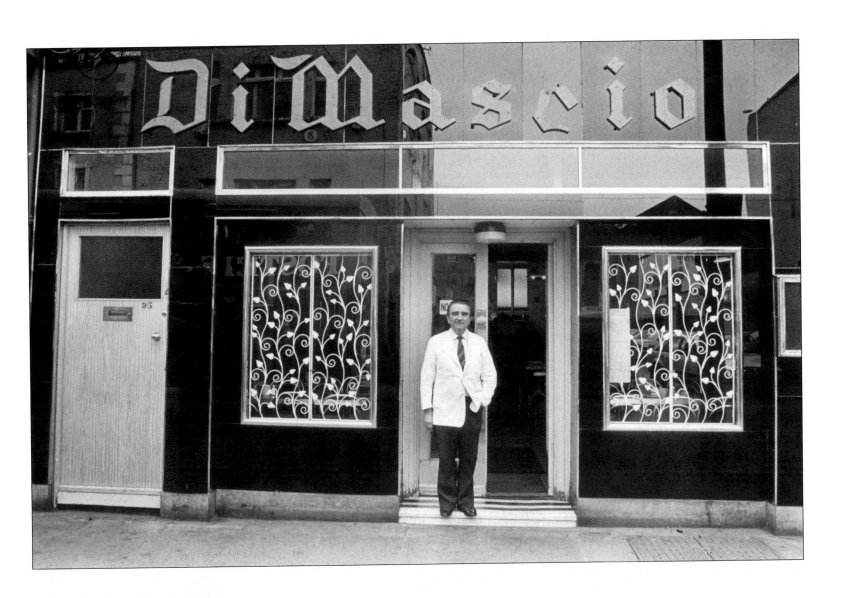

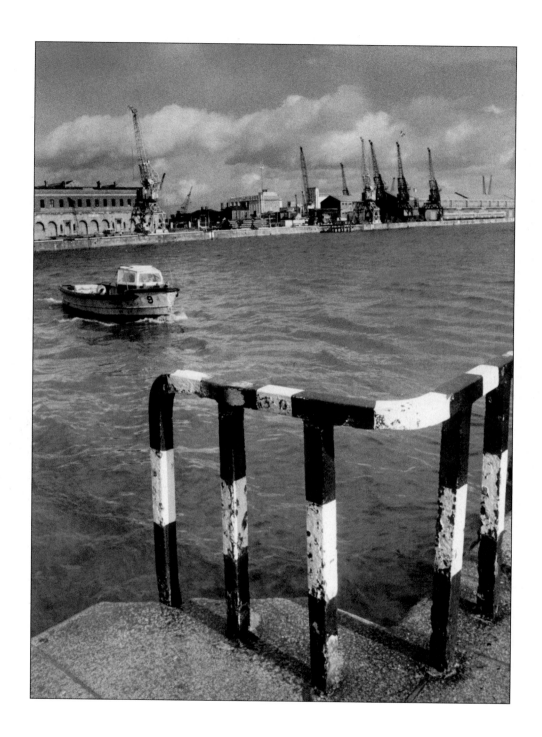

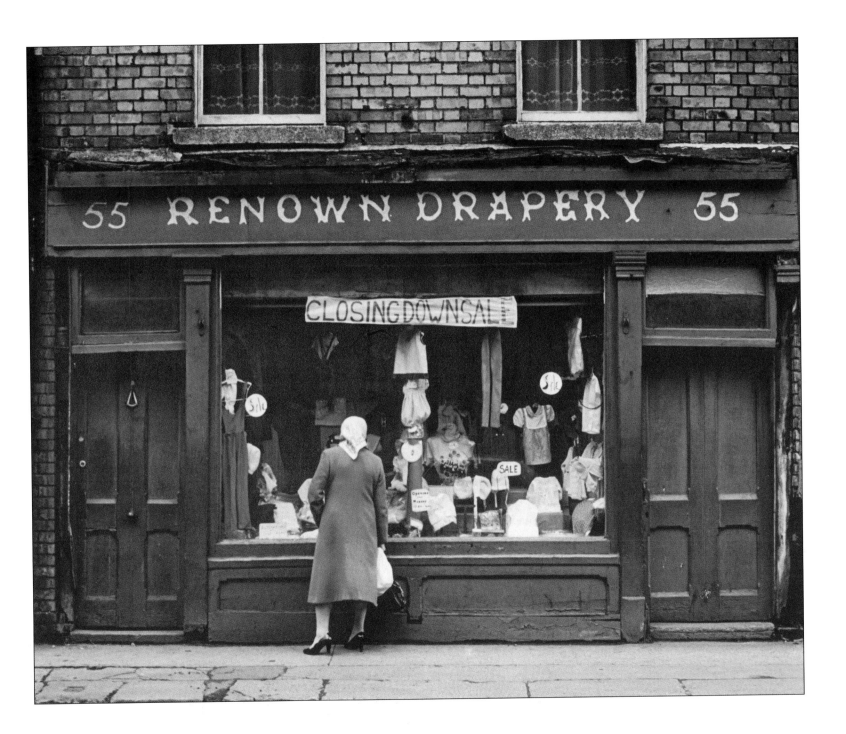

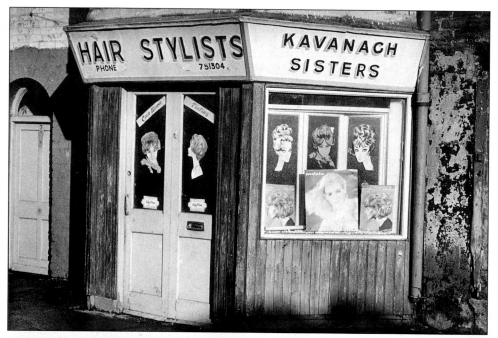

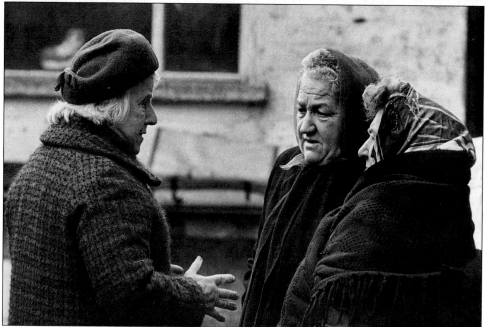

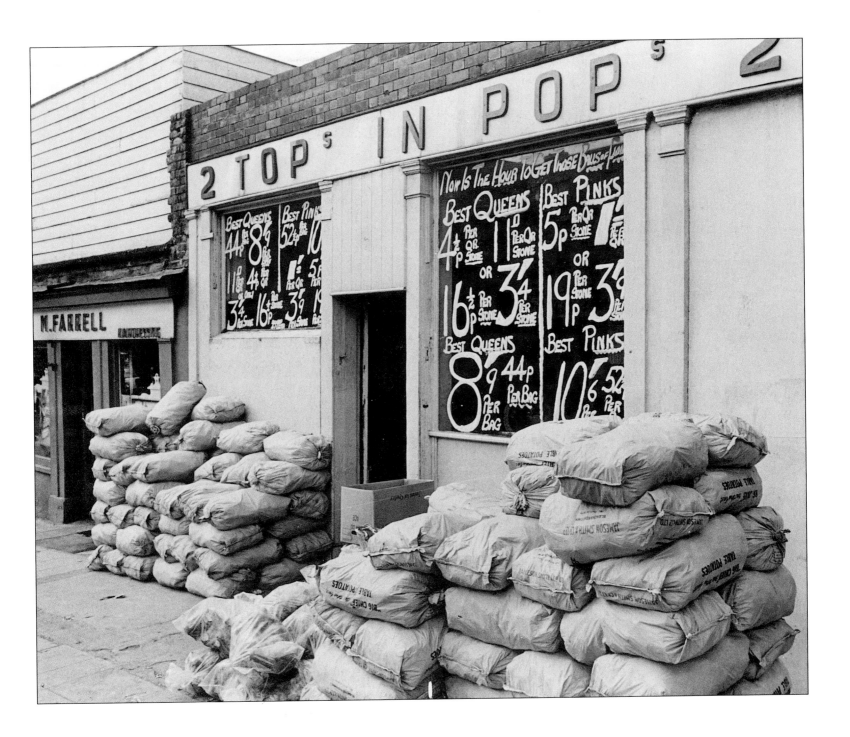

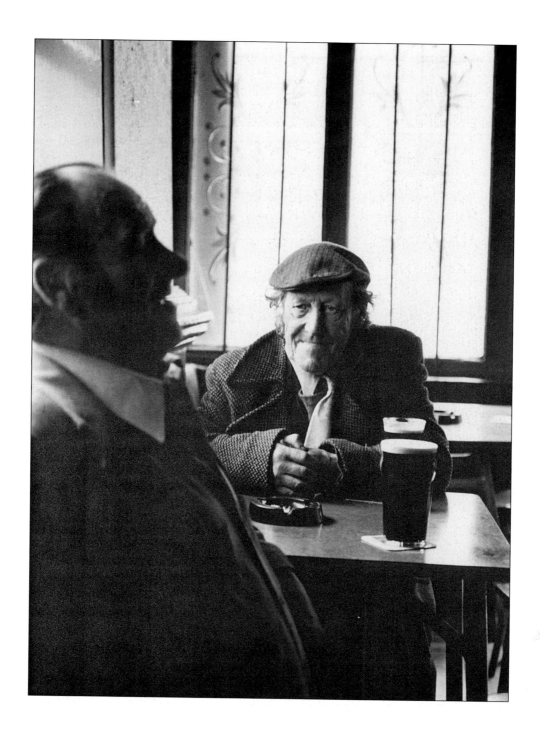

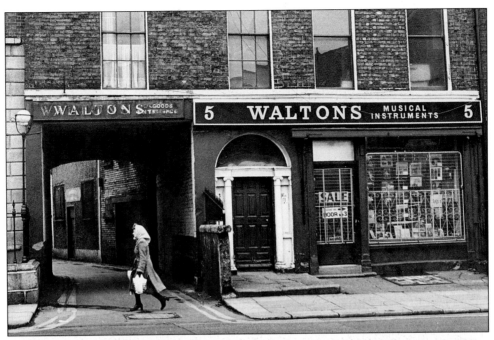

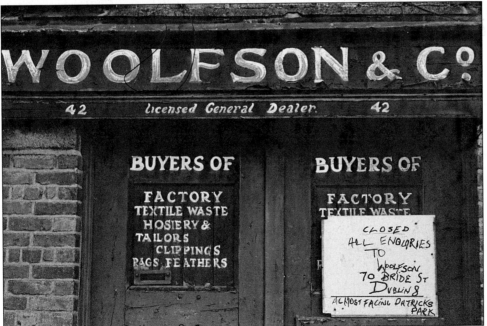

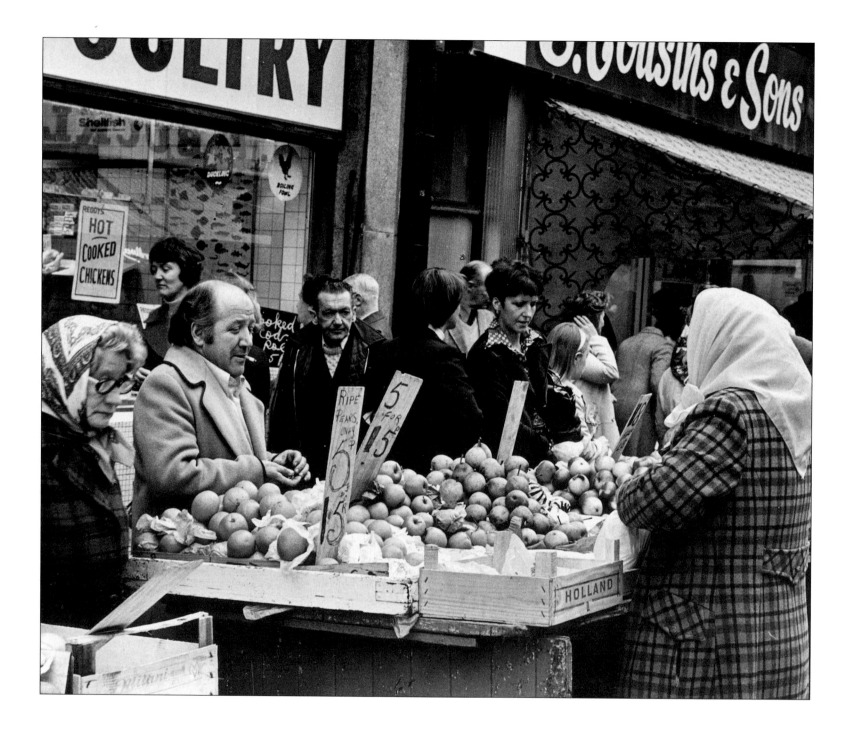

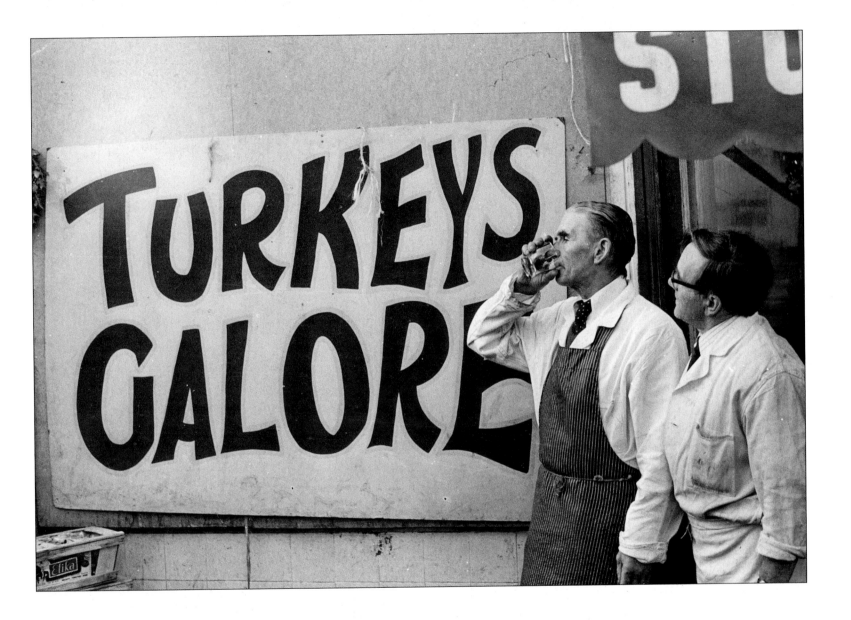

4

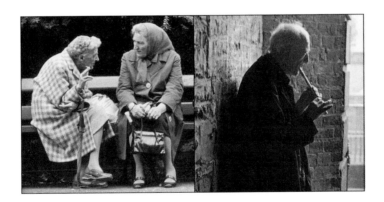

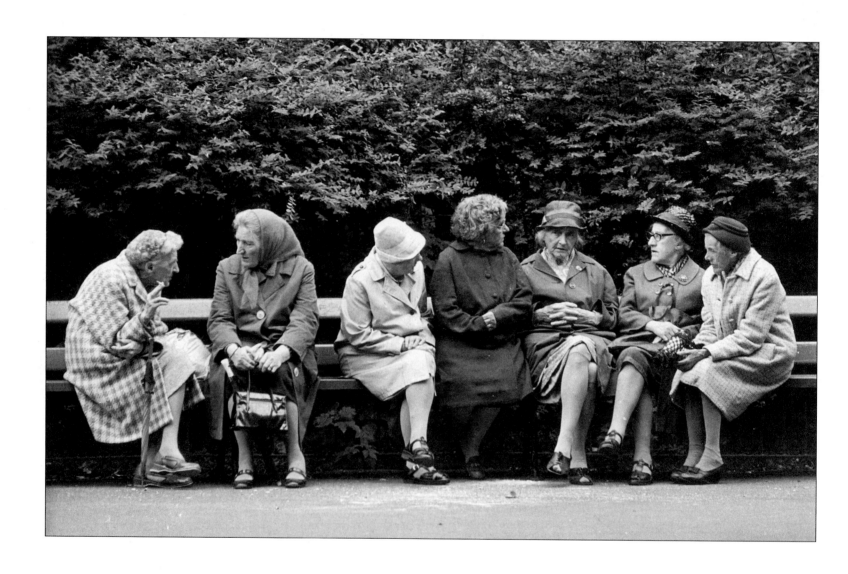

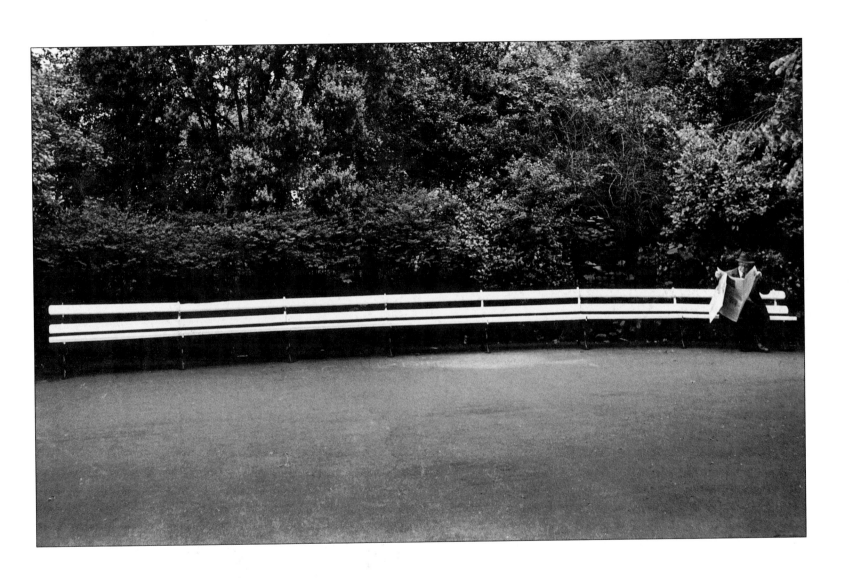

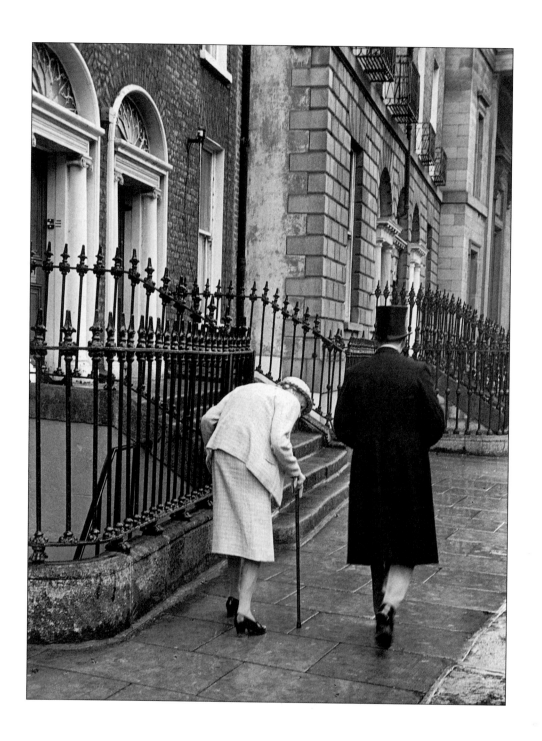

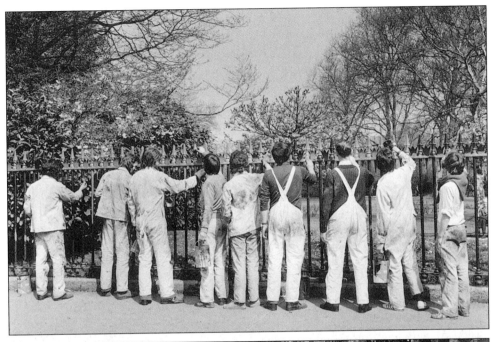

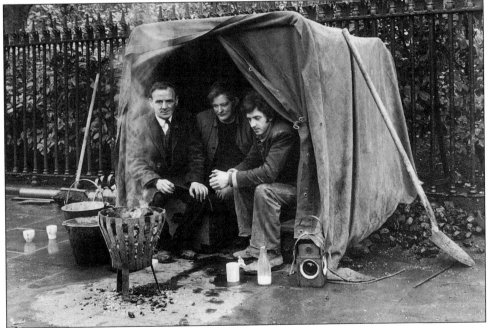

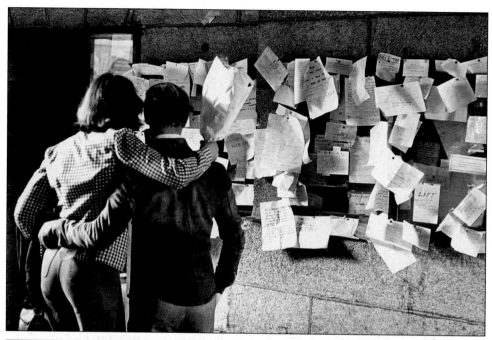

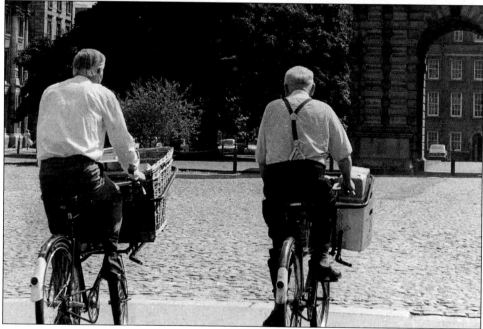

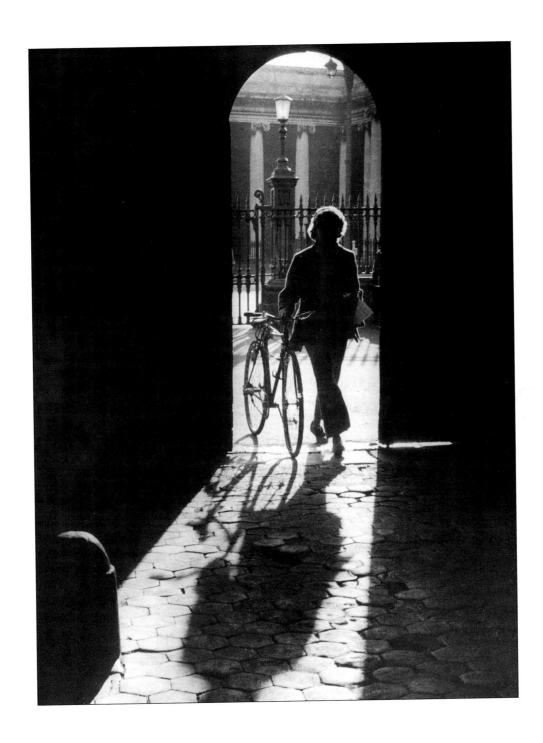

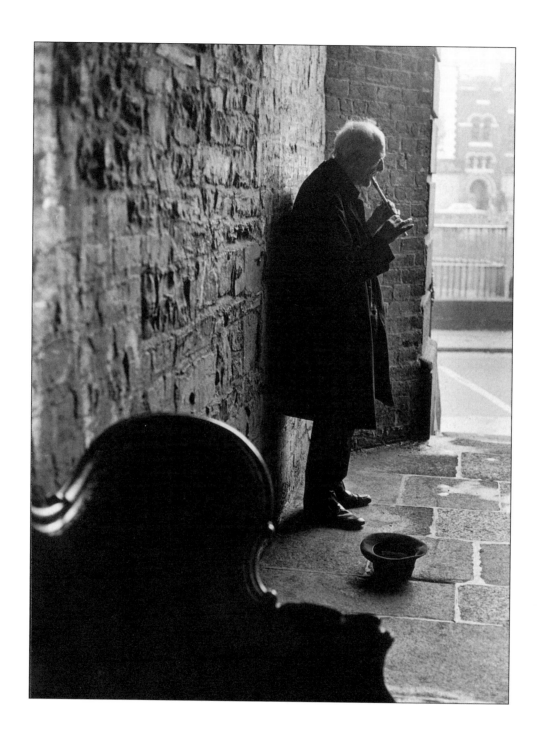

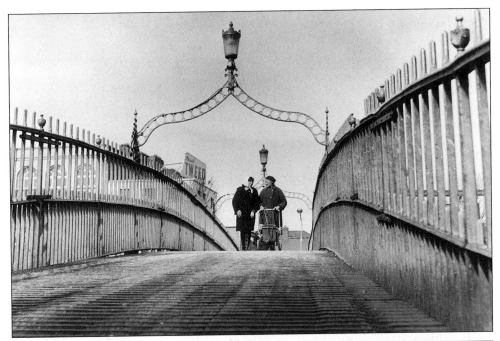

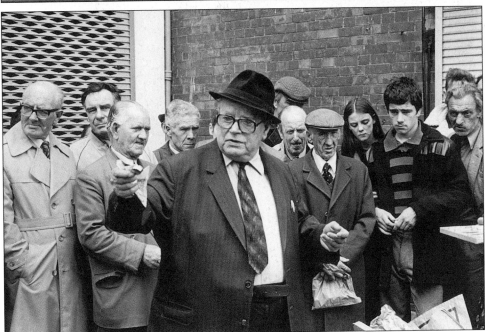

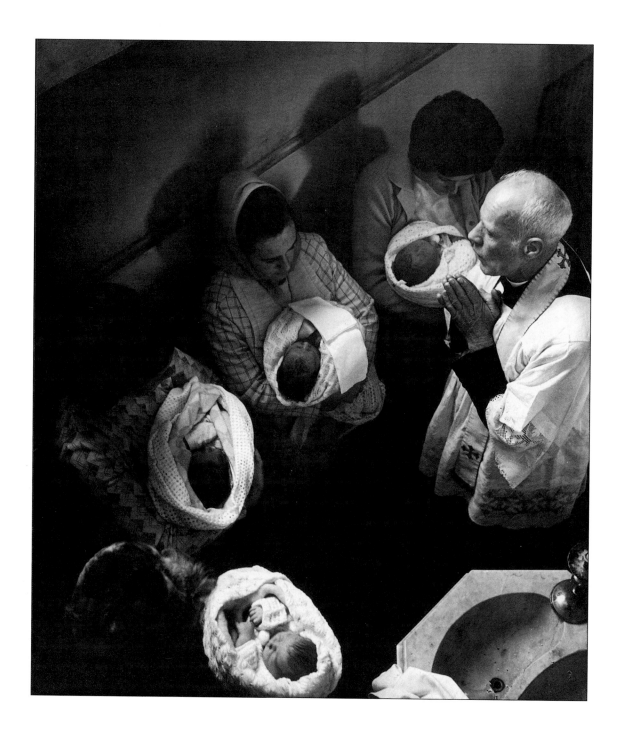

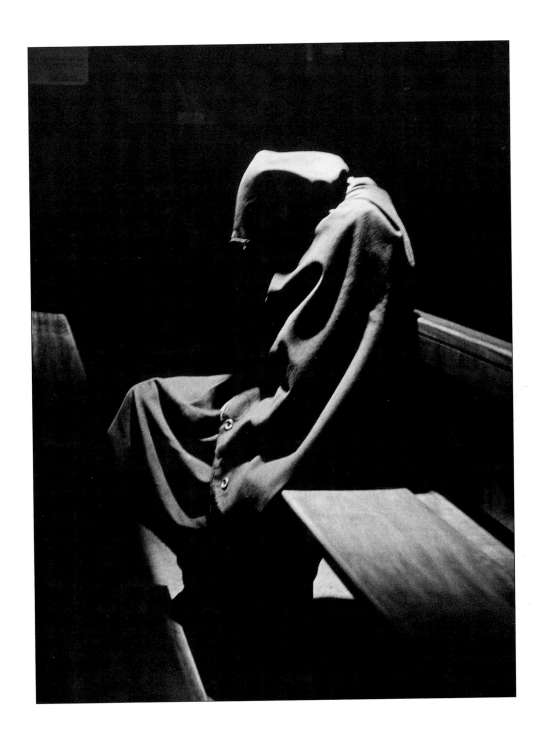

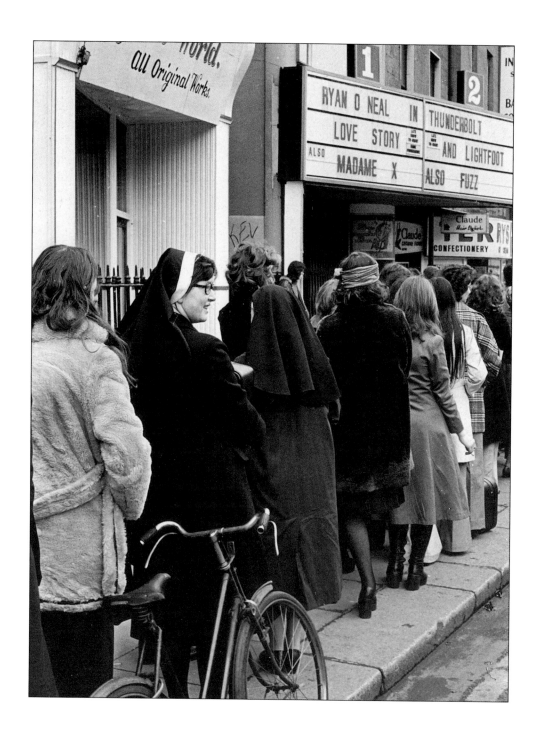

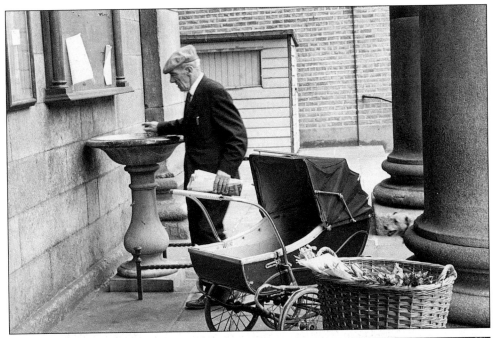

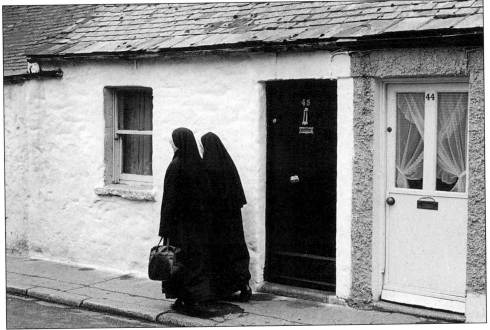

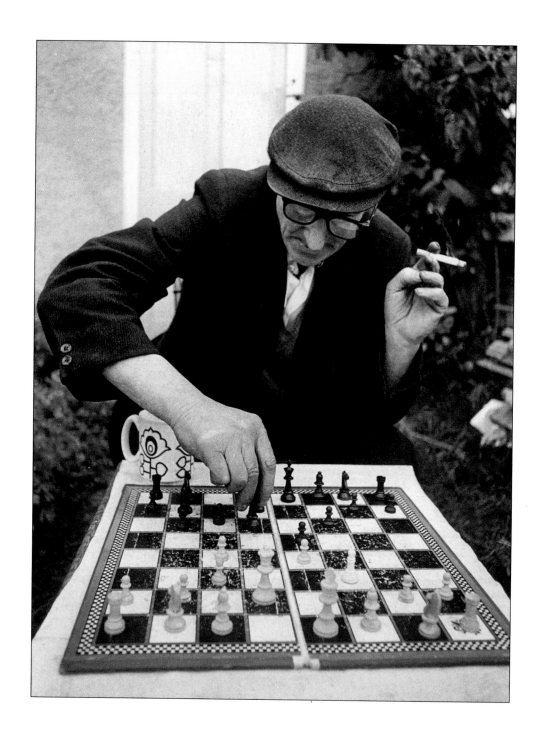

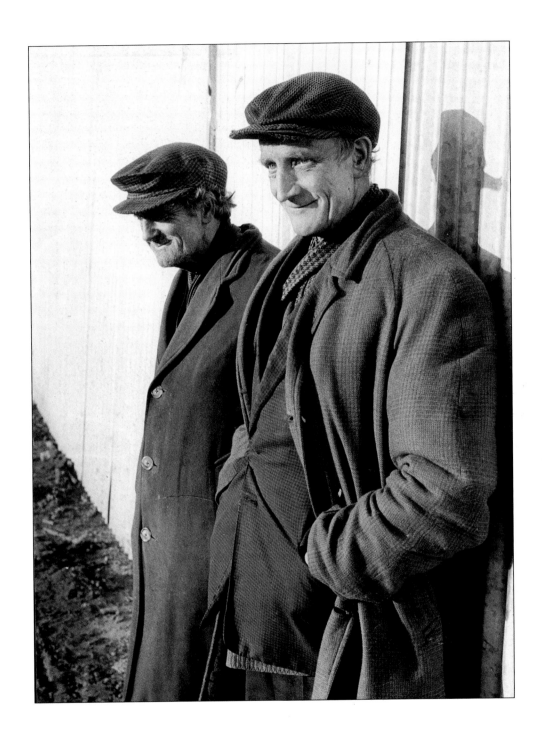

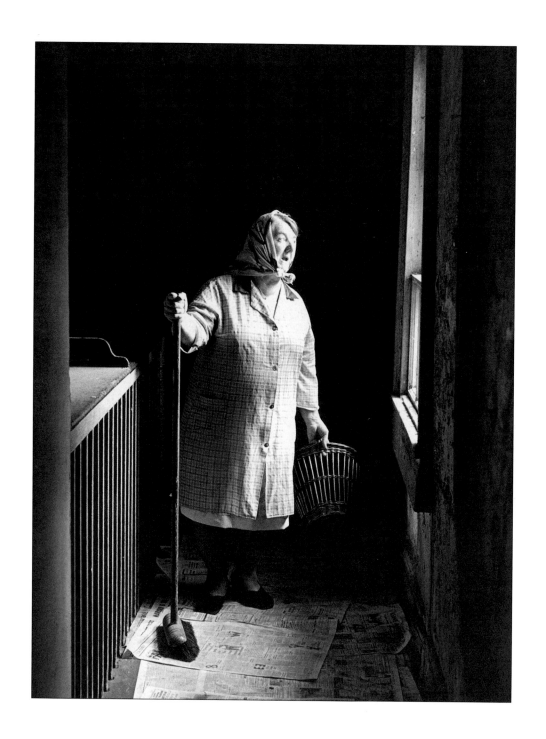

84

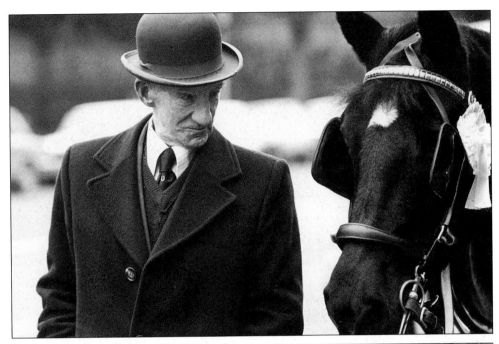

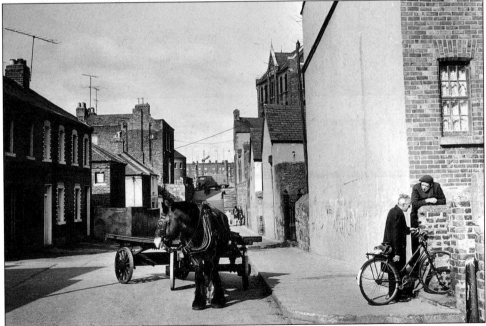

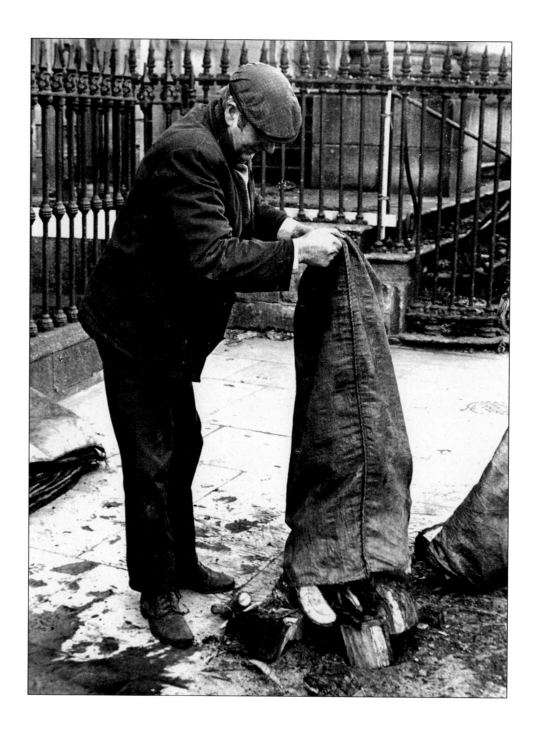

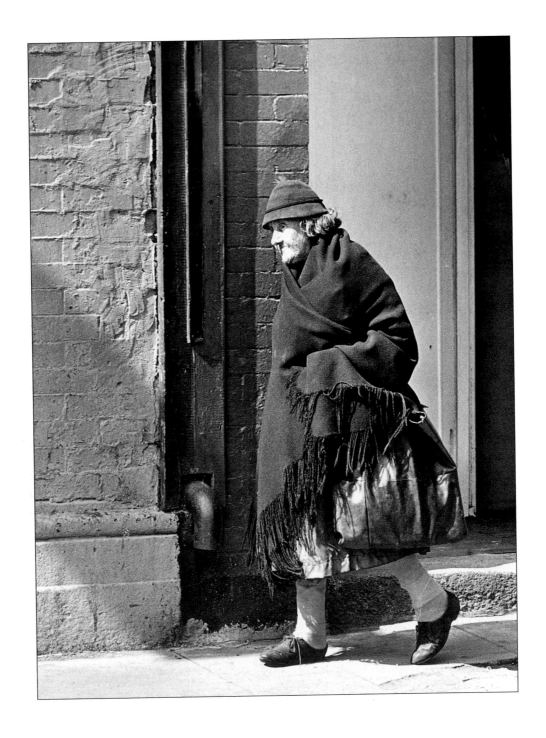

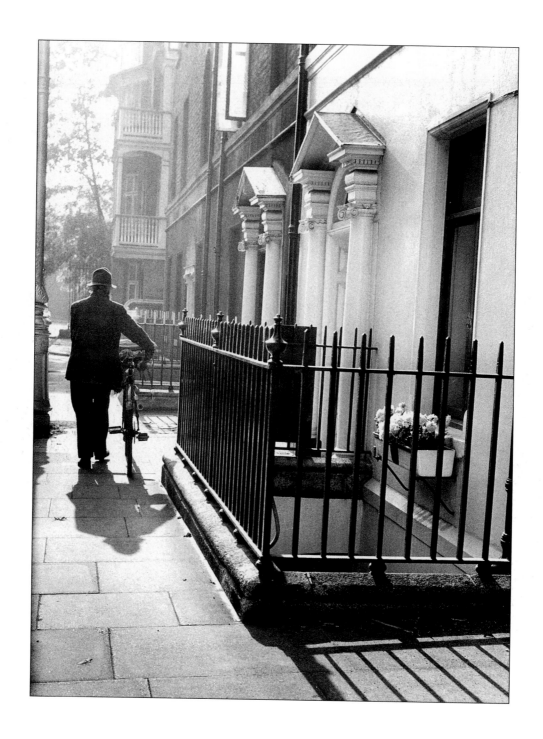

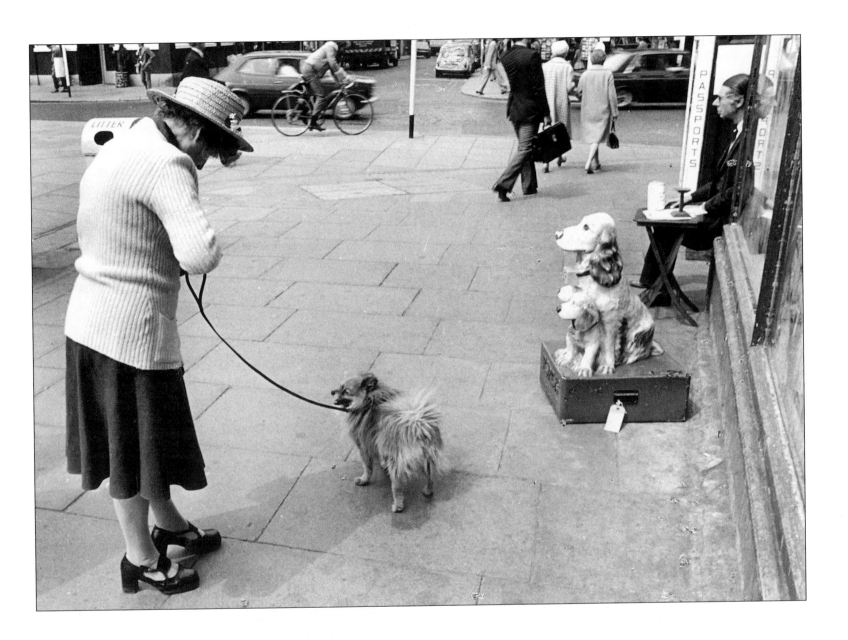

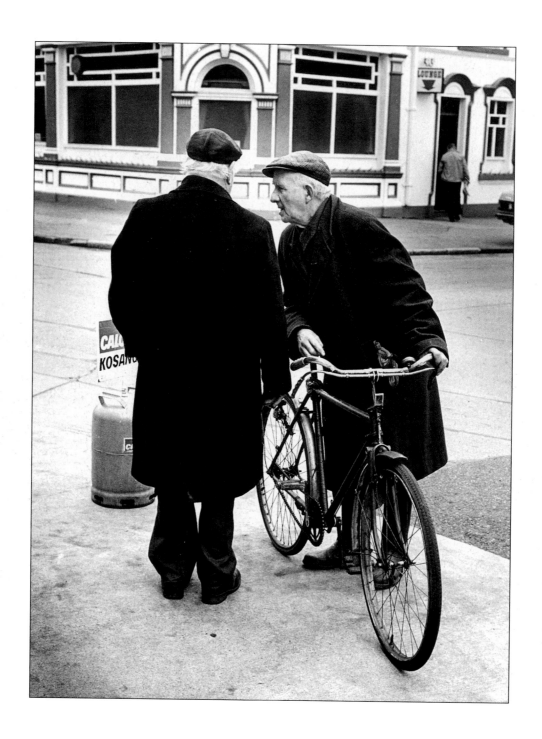

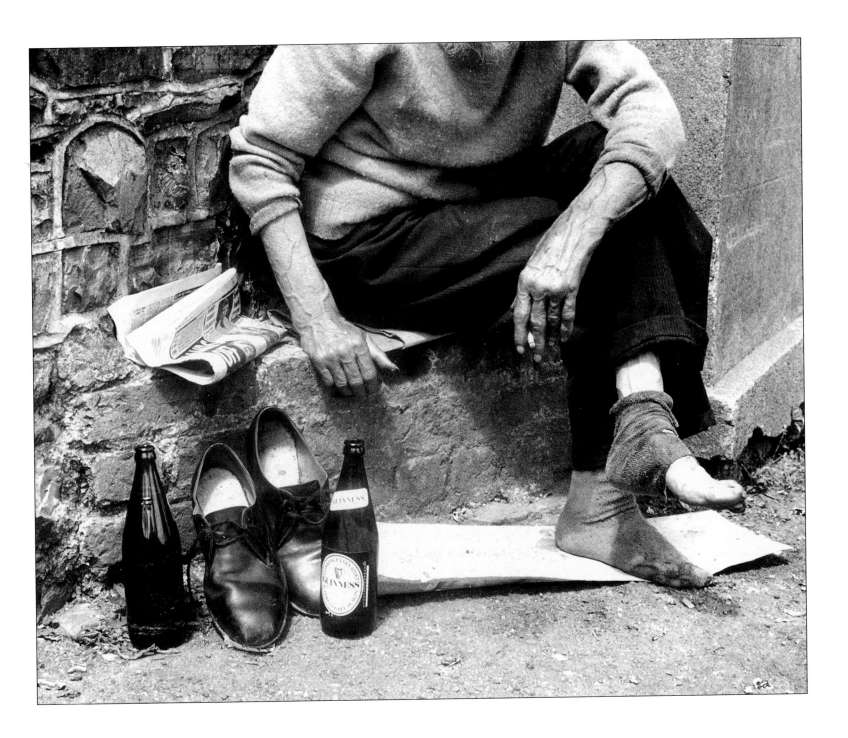

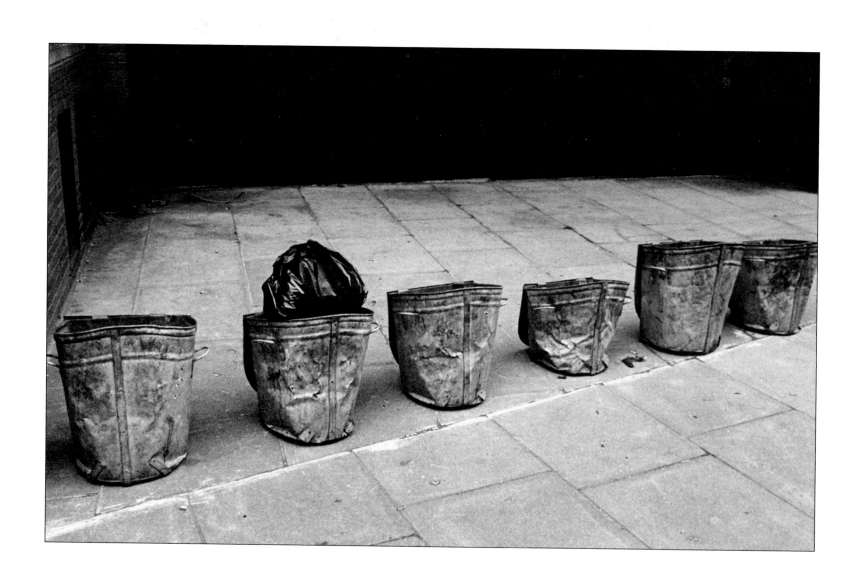

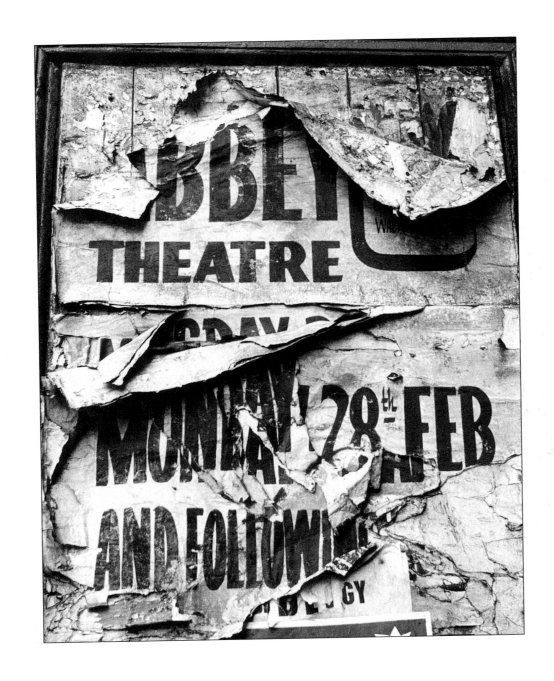

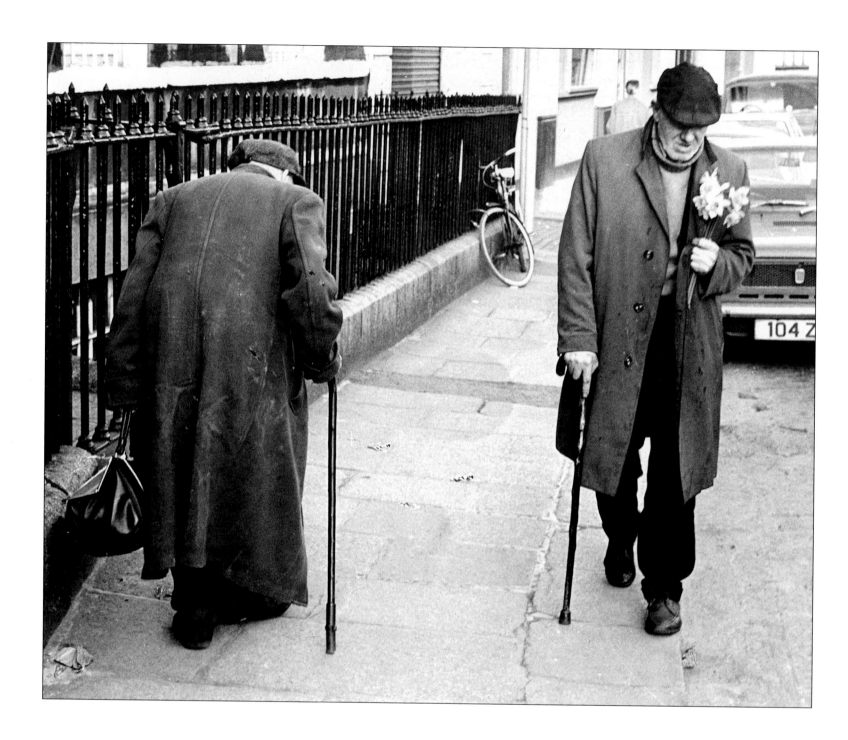

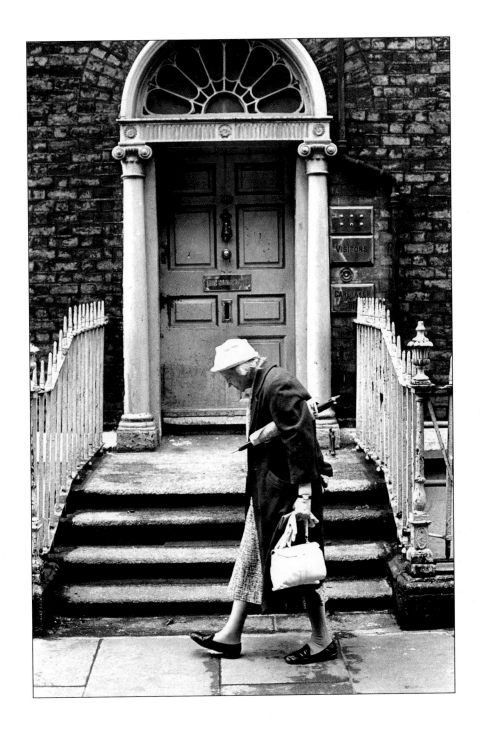

5

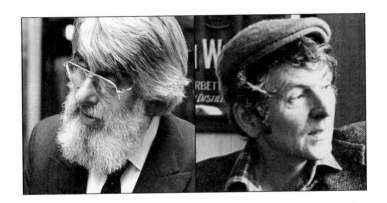

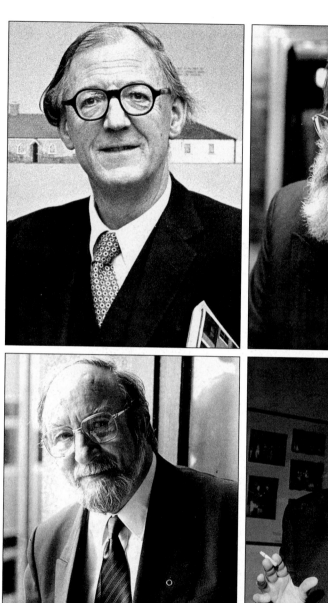
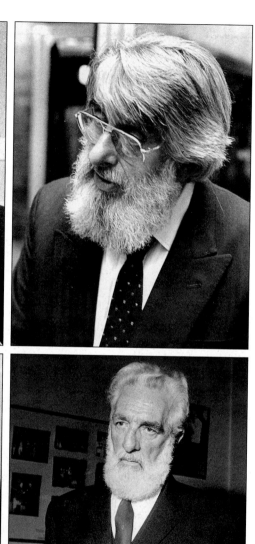
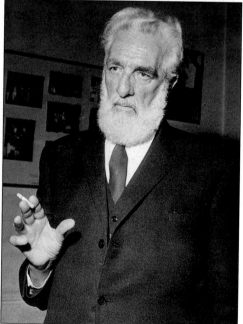

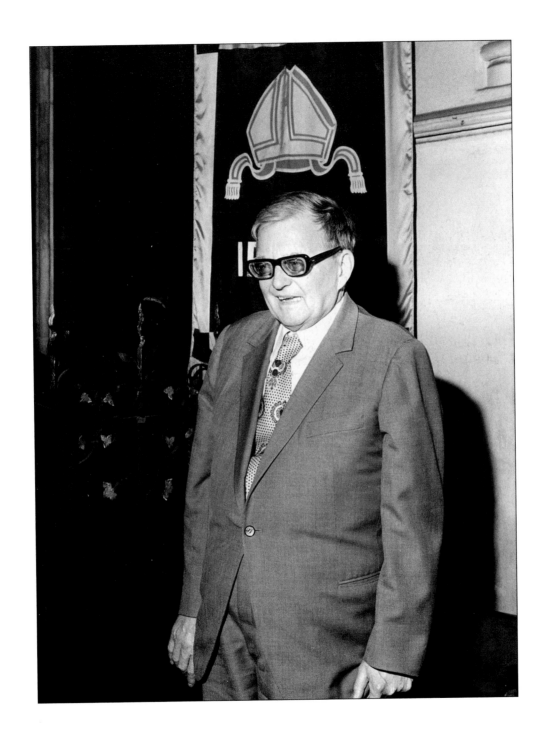

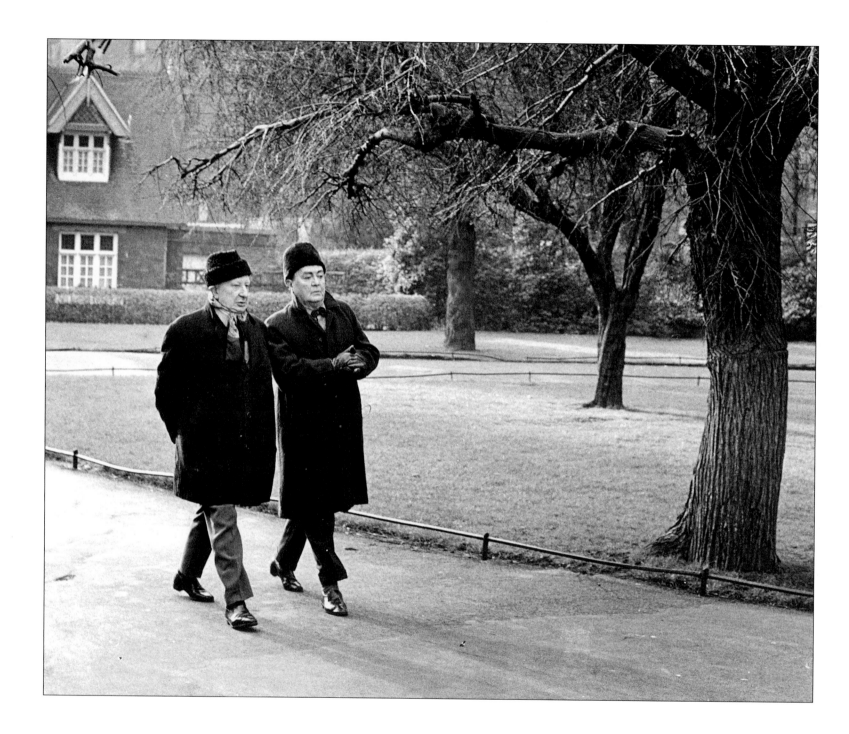

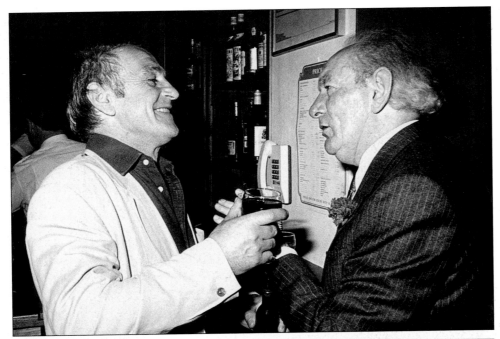

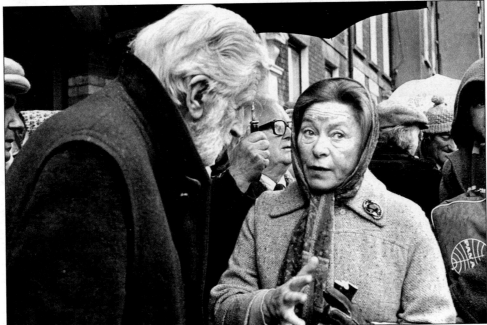

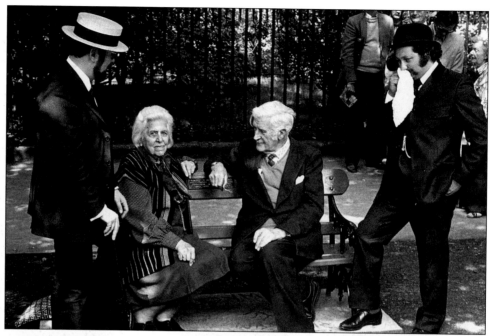

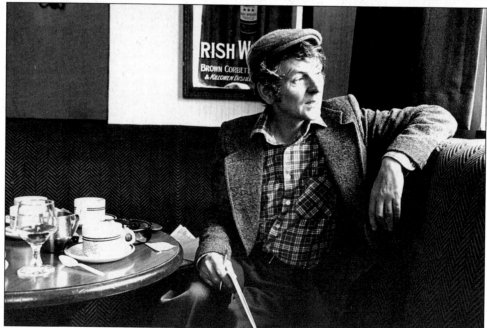

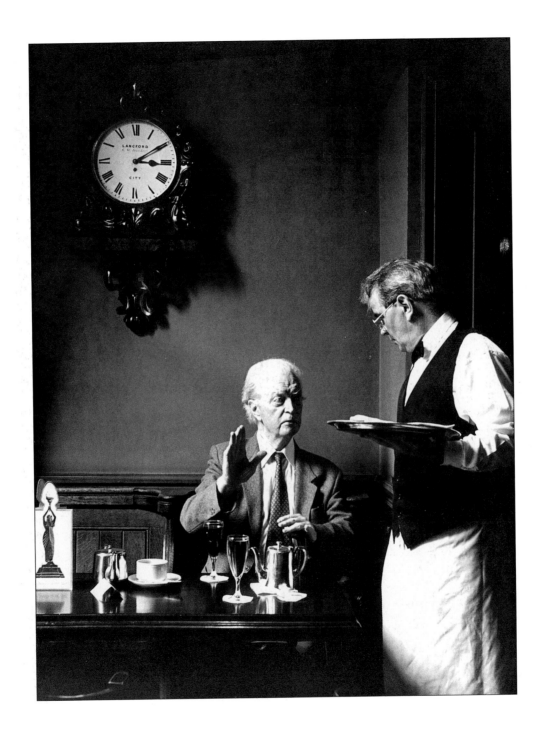

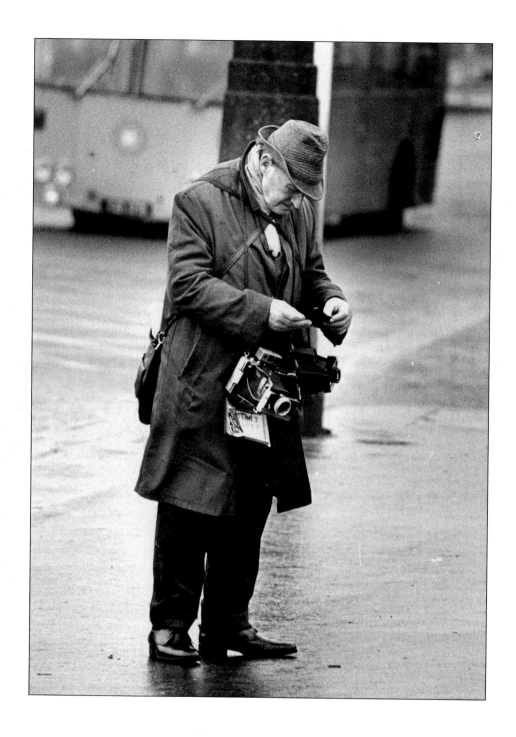

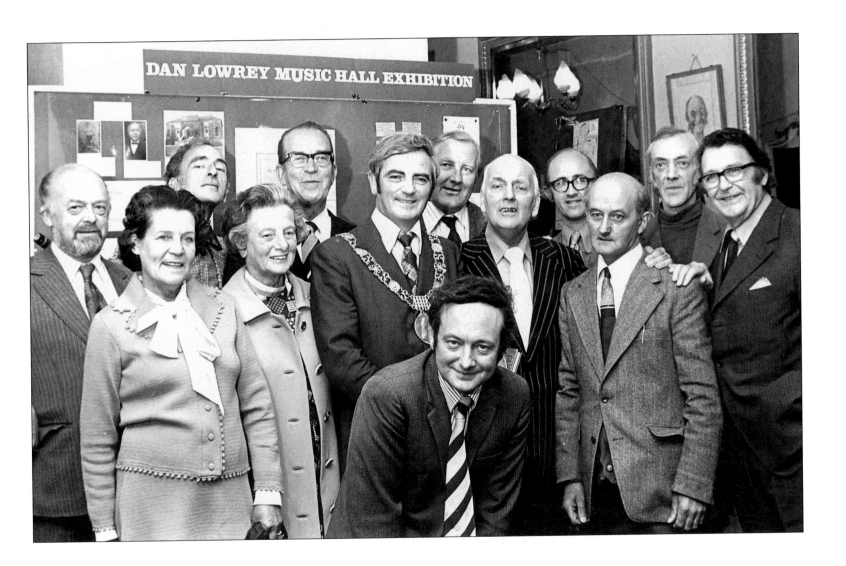

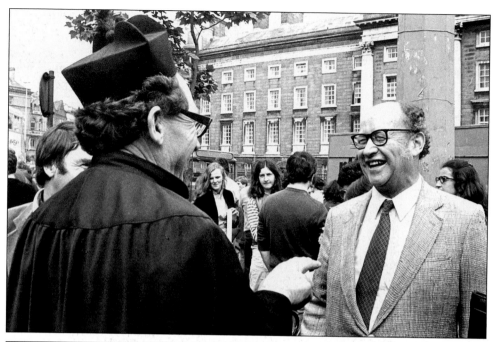

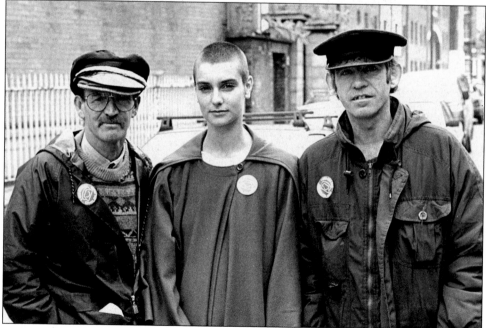

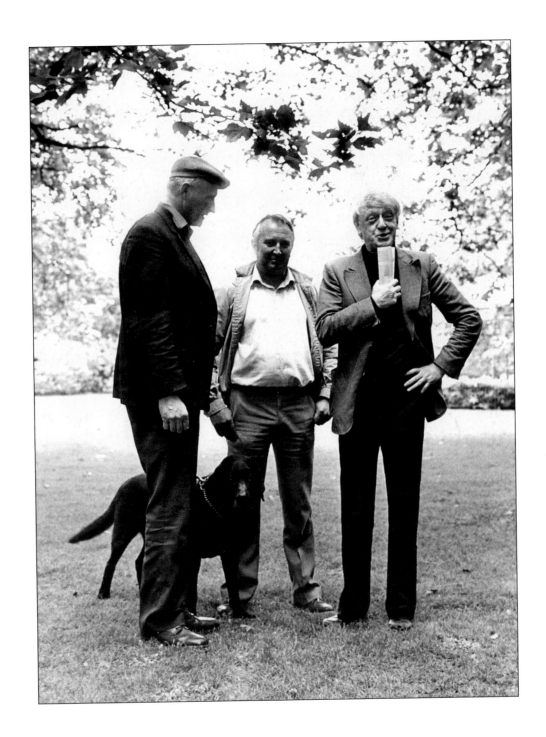

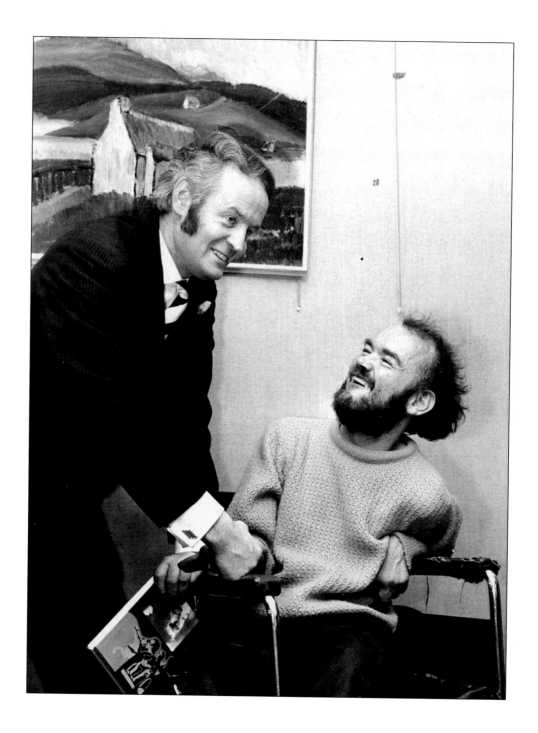

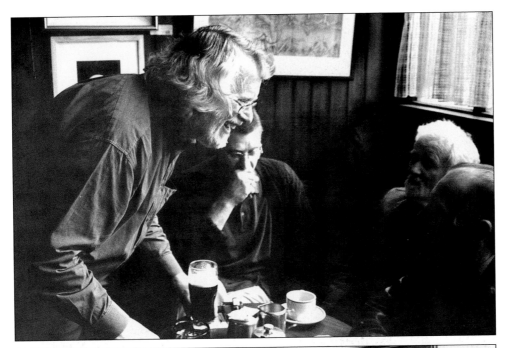

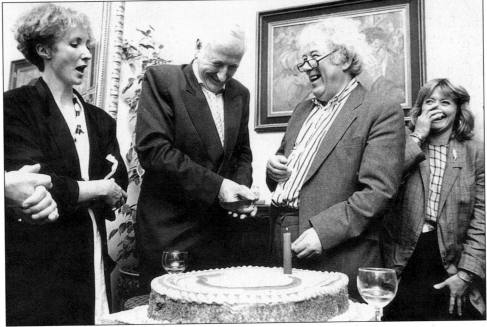

6

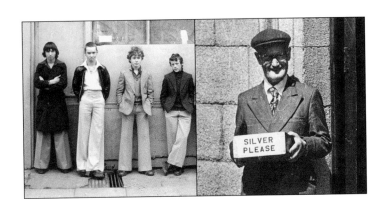

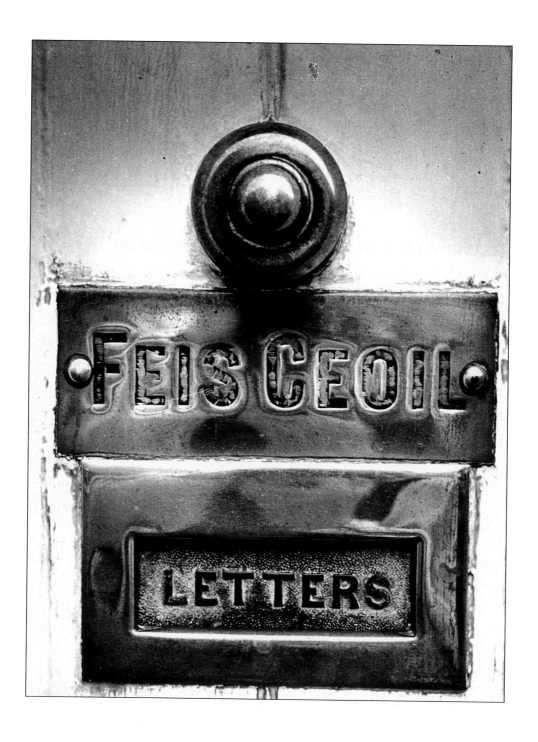

St. Mary's Church
Founded 1627.

BAPTISMS IN THIS CHURCH
Brinsley Sheridan
1751.
Theobald Wolfe Tone
1763.
Sean O'Casey
1880.

MARRIAGE
Arthur Guinness to Ann Lee
1793.

BURIALS
Thomas Brinsley Sheridan.
Mary Mercer.
Lord Norbury.

PREACHED HERE
Rev. John Wesley
1747.

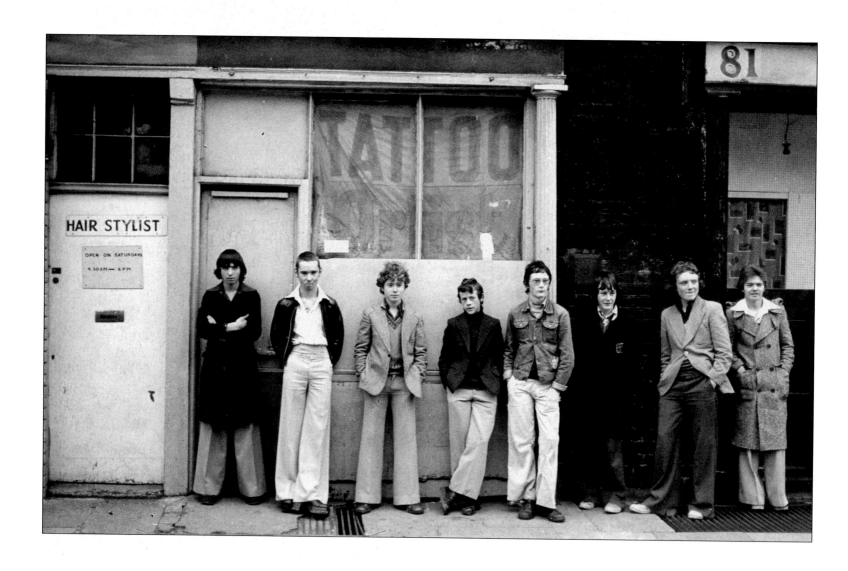

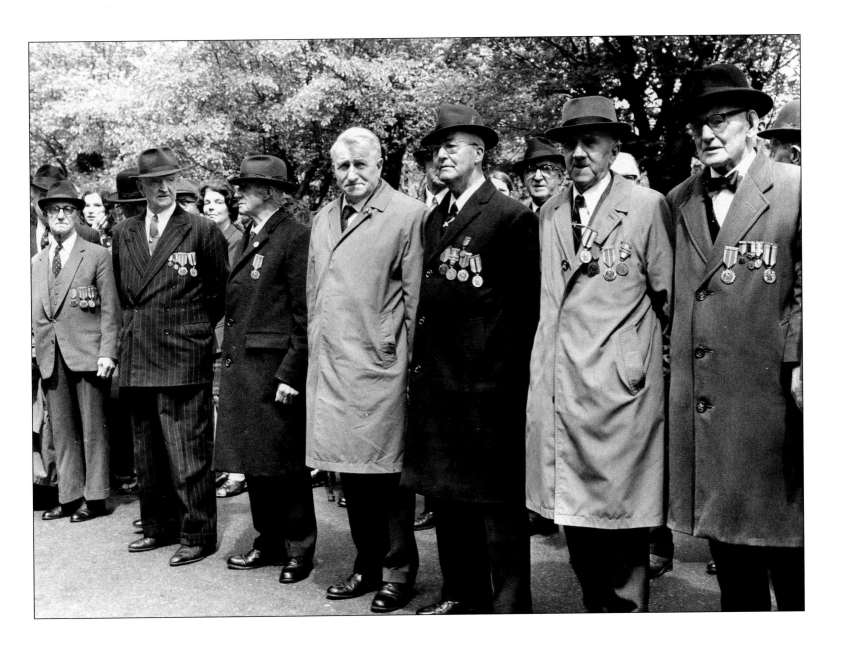

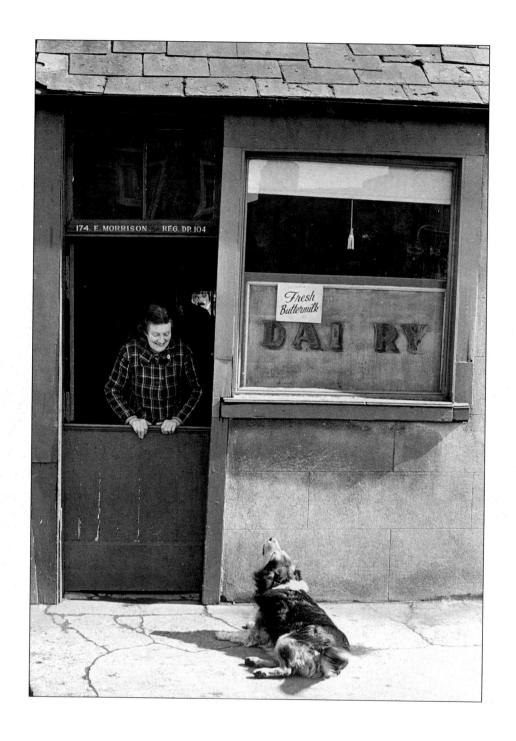

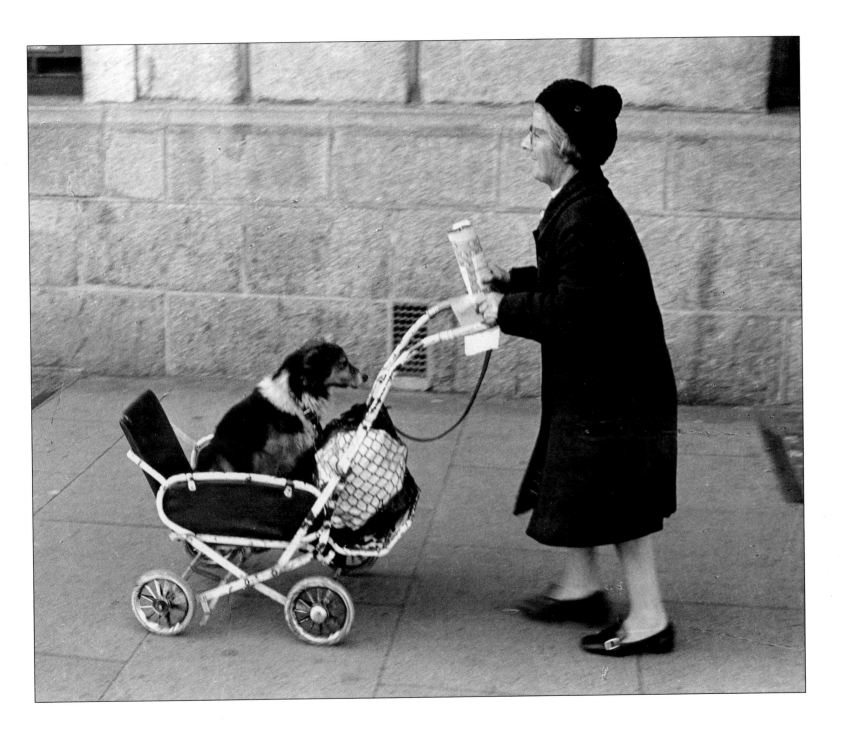

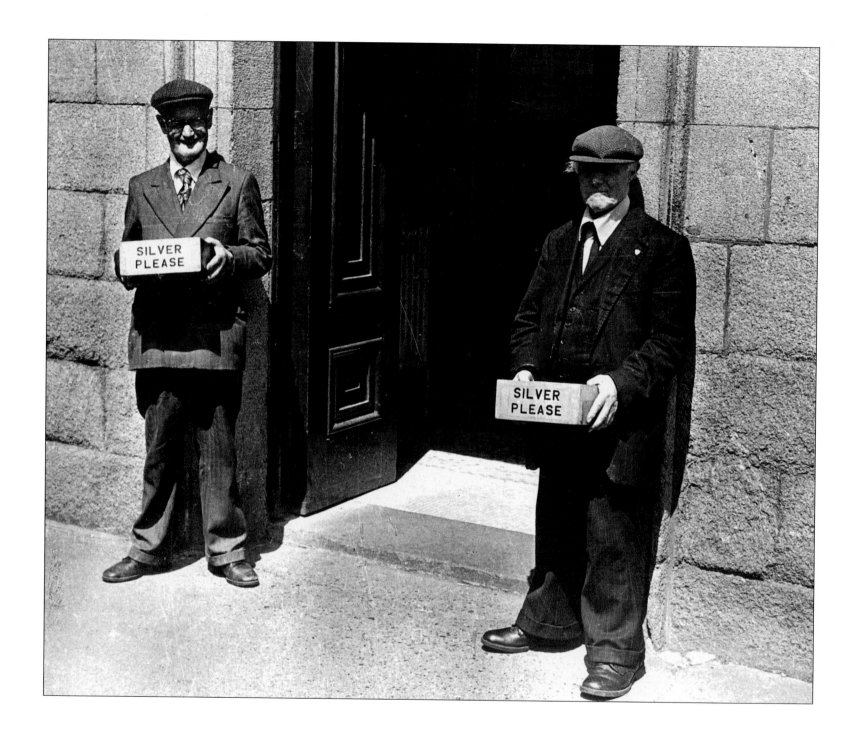

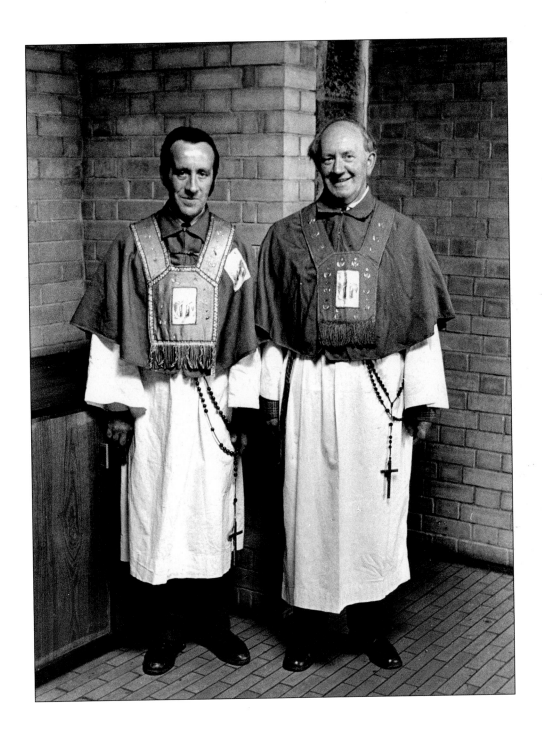

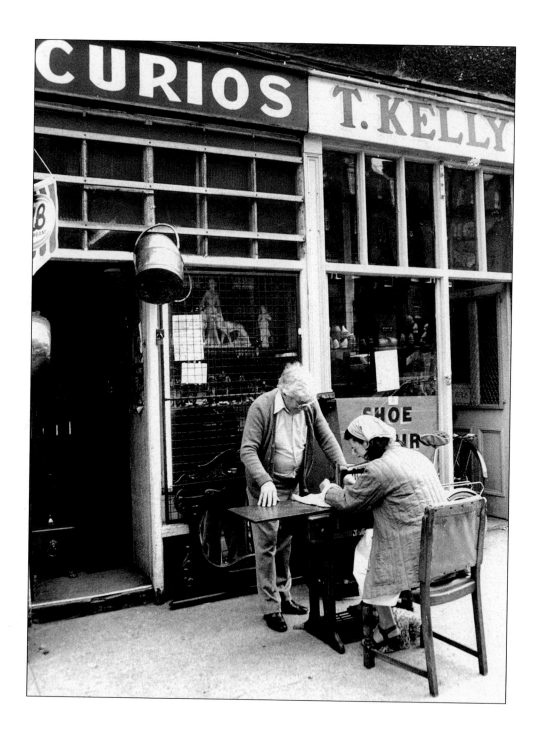

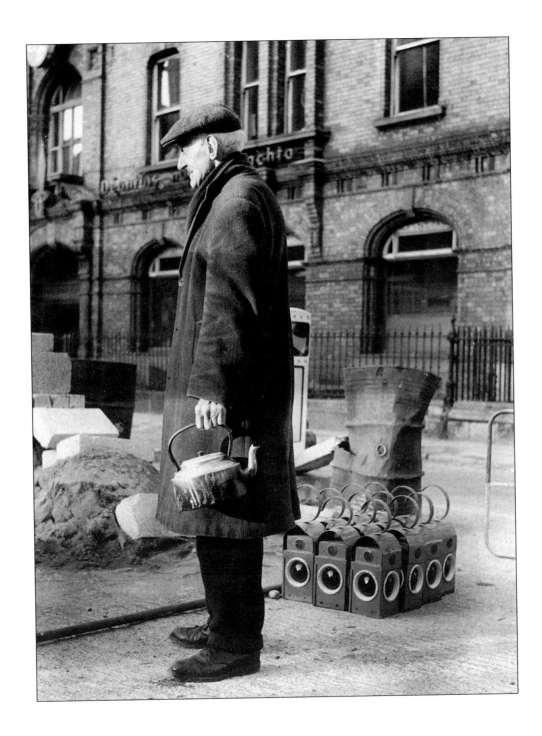

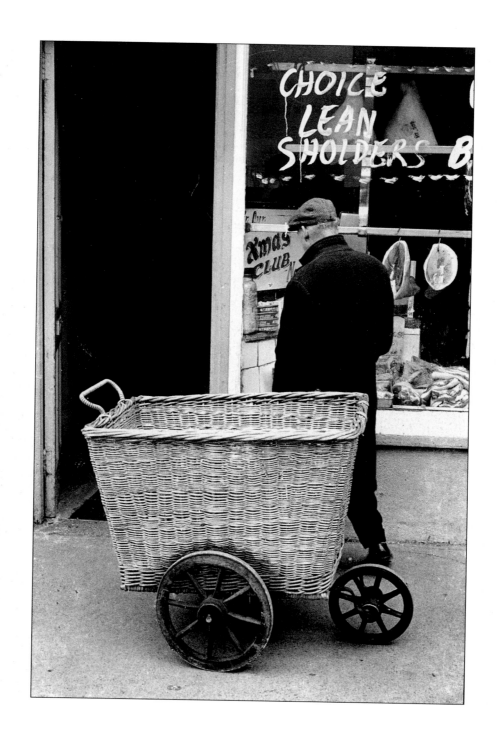

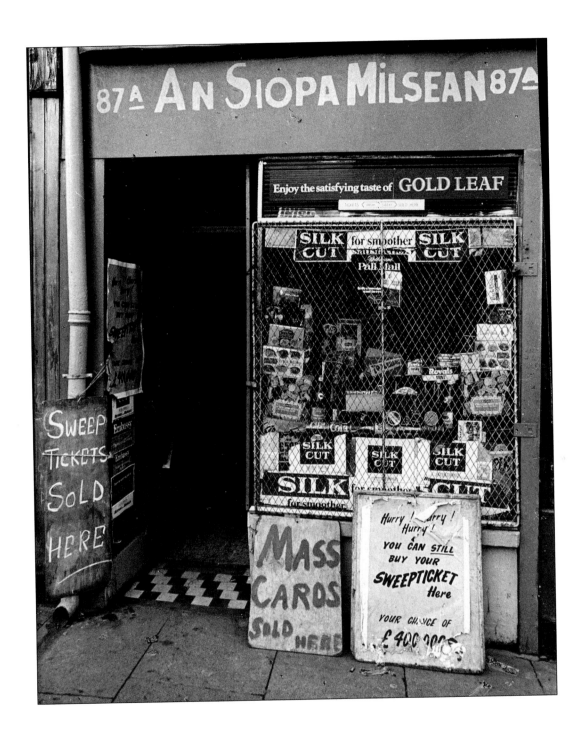

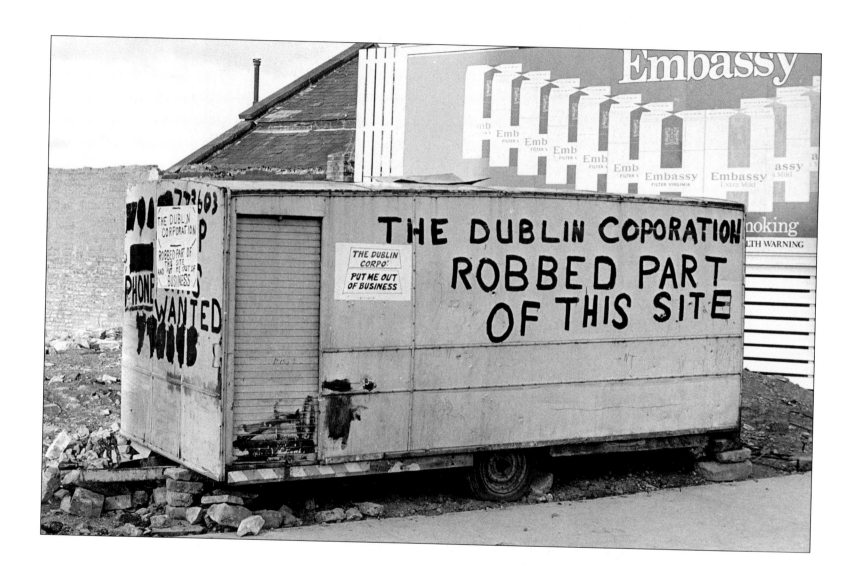

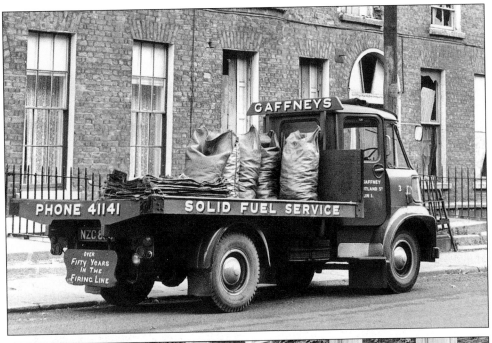

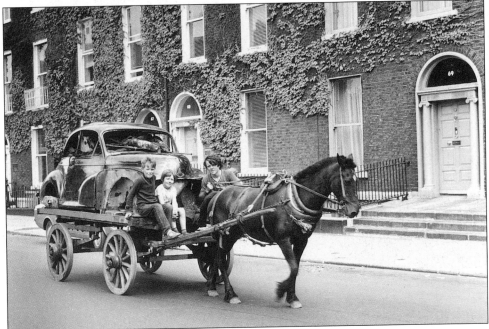

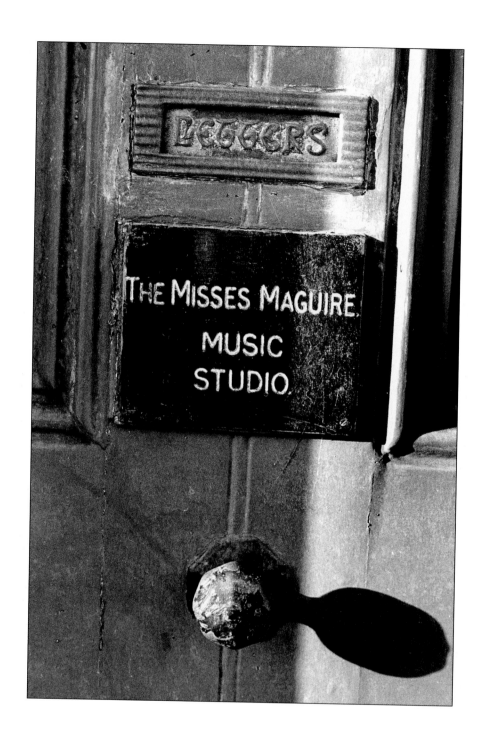

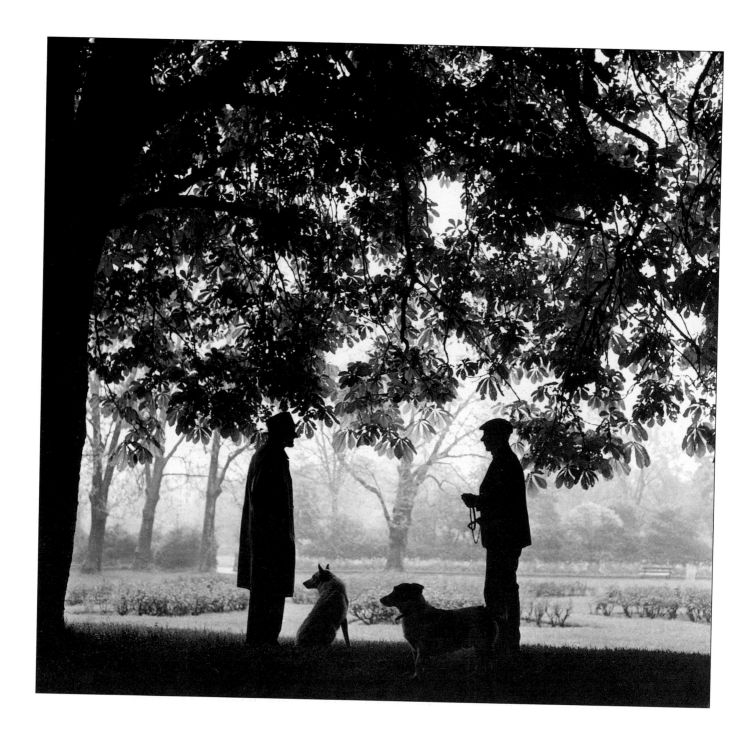

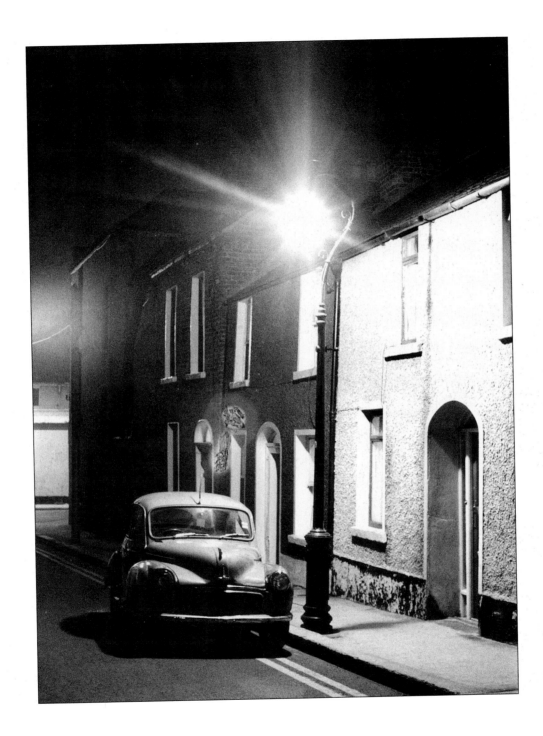

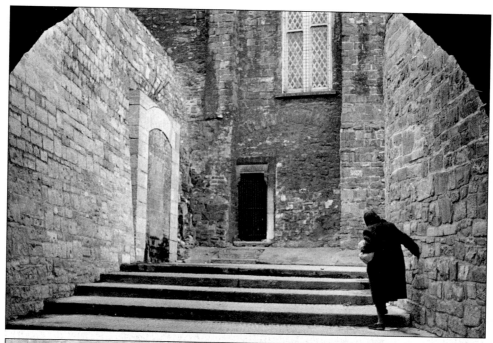

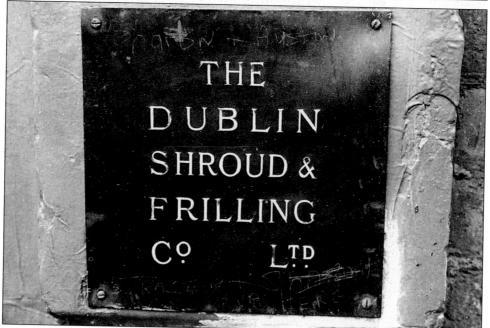

THE
DUBLIN
SHROUD &
FRILLING
Cº. LTD.

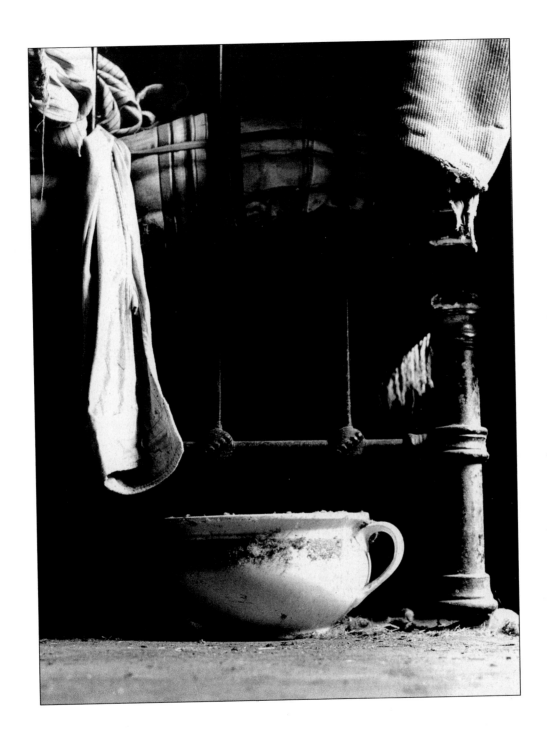

CAPTIONS

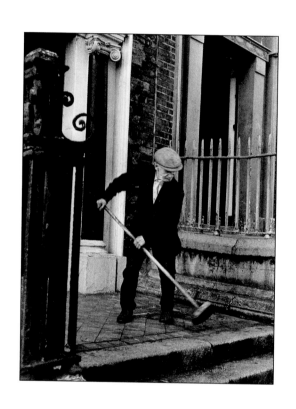